SECRET LIVERPOOL

Mark & Michelle Rosney

AMBERLEY

Acknowledgements

Many thanks to the following people, whose invaluable help and endless encouragement made this book possible: Janette Fleming, Julie Connolly, Anita Millea; the staff at the Merseyside Maritime Museum – in particular Jazz Vanducci, Danny Wright, Robert Cook & Sam Vaux; the local archive team at Liverpool Central Library; Gordon Roberts – for kind permission to use his photo of the Formby Footprints, Leslie Gabriel from the Ancient Chapel of Toxteth; Nigel Sharp – Parks Development Officer, Liverpool City Council; Sean, Jenny and all the staff at the Dome, Grand Central Hall and Vicky and June from Night Vision Investigations.

In memory of my mother Elizabeth, who always knew that one day I would make it into print.

Map contains Ordnance Survey data © Crown copyright and database right 2015.

First published 2015

Amberley Publishing
The Hill, Stroud, Gloucestershire, GL5 4EP
www.amberley-books.com

Copyright © Mark & Michelle Rosney, 2015

The right of Mark & Michelle Rosney to be identified as the Authors of this work has been asserted in accordance with the Copyrights, Designs and Patents Act 1988.

ISBN 978 1 4456 4053 2 (print)
ISBN 978 1 4456 4086 0 (ebook)

British Library Cataloguing in Publication Data.
A catalogue record for this book is available from the British Library.

Typesetting by Amberley Publishing.
Printed in Great Britain.

Contents

Introduction

From its humble origins as a small fishing village, Liverpool has grown to become one of the best known cities in the world. Diverse in culture and rich in architecture, the city that we know today has over 800 years of history packed into its streets and suburbs. Not much is written about Liverpool before 1207, but from ephemeral traces found around the region it is known that the area has been occupied for a very long time, at least as far back as the late Neolithic period.

However, Liverpool's story officially began with King John's charter of 1207. This established the area as a borough, which was in turn the catalyst that led to its expansion into the city we see today. Much has been written in other books about the minutiae of each pivotal moment in the city's development that would be pointless to reproduce here; this book therefore aims to do something slightly different.

Contained within these pages is a veritable magical mystery tour of lesser known facts and stories from the history of Liverpool, which paint a warmer, more intimate picture of the city. Included within are stories of some of the people who have made a lasting impression on the city. There is that of the architect who won the commission to design the magnificent Anglican Cathedral (the fifth largest cathedral in the world), despite his only previous design project being the creation of a pipe stand, and that of an eccentric Liverpool poet who, obsessed by a Swiss psychiatrist's dream, established an arts venue in an old dilapidated warehouse that became the creative heart of the city, and ultimately, the rest of the world.

Also included here are some slightly quirky sights, places and artefacts that have a place in the narrative of the city, such as a mysterious shell-encrusted boat that has remained on display in an abandoned shop for over thirty years, and the semi-permanent mirage that can be seen over the city from certain vantage points.

Hopefully there is something in here for almost everyone to enjoy and, if you are feeling adventurous, go to see for yourself.

1. Ancient Liverpool

INTRODUCTION

Although the first ever recorded reference to Liverpool dates back to around 1207 and King John's charter, there are still visible clues, scattered across the region, which show that human activity in the area goes as far back as the late Neolithic Age around 5,000 years ago.

We now take a look at the evidence of ancient occupation that survives to this day, from the prehistoric sub-fossilised footprints that can be found along the Formby shoreline at low tide, to the ancient standing stones and remains of burial chambers scattered around south Liverpool. Each gives a tantalising insight into the lives and practices of the first settlers in Liverpool.

THE FORMBY FOOTPRINTS

Some of the most remarkable, and undoubtedly some of the oldest, artefacts from human activity in the region can be found along the shoreline north of Formby Point. As the daily tide recedes, it takes with it layers of ancient silt from the beach, which sometimes uncovers trails of prehistoric human footprints made by Neolithic hunter-gatherers as they went about their day-to-day activities around 5,000 years ago.

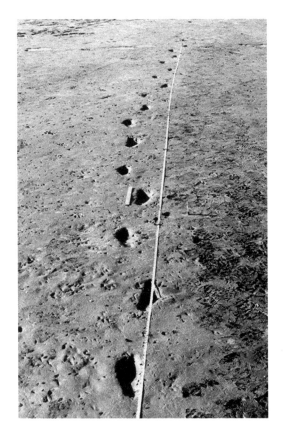

Prehistoric human footprint trail on Formby Beach. Photo Copyright: Gordon Roberts.

The prints have miraculously survived into the twenty-first century due to a fortunate set of circumstances. Around 7,500 years ago, a series of sand bars emerged just off the coast, resulting in the formation of an intertidal lagoon between the sand bars and shore. The sand bars not only made the tidal action gentler, but also led to an increased deposition of silt in their wake. For around 3,000 years, animals, birds and humans walked along the silted shoreline leaving their footprints in the mud. Some of these prints became preserved because they were baked solid by the heat of the sun and subsequently buried by successive layers of silt and sand brought in with each tide.

Around 4,500 years ago, the shoreline gradually drifted westwards, leaving the buried prints far behind inland. Today, due to rising sea levels and coastal erosion, the shoreline has returned to the same position it once occupied in the late Neolithic age. This means that with each receding tide, a thin layer of silt is stripped off the beach, exposing the ancient footprints once again.

The footprints are not permanent. Due to their incredibly fragile nature, once exposed, these sub-fossils do not survive for very long. It is an incredibly ironic fact that the tidal action that uncovers them is also the very same force that inevitably destroys them. Their lifespan is incredibly short, measured in mere hours – revealed by the outgoing tide, erased by the next incoming tide.

What makes the prints at Formby Point all the more remarkable is the fact that prehistoric hominid footprints have only been discovered to date in sixty-three sites around the world, and of all those sites, Formby Point has yielded the greatest number of prints and trails found in one place. Since the late 1980s, over 200 trails of human footprints have been recorded and studied.

If you are lucky enough to come across some of these ephemeral footprints, it is hard not to feel a sense of awe and wonder, for some of them were placed in the ancient mud thousands of years before the building of Stonehenge or the Egyptian pyramids. However, unlike either construction, the footprints reveal far more about the people who made them than any man-made structure ever could.

By measuring the shape and size of the footprints and distance between them, it is possible to work out the individual's gender, estimate their height and calculate the speed at which they were walking across the ancient mudflats. By careful study of the prints in relation to one another, it is also possible to get an idea of the sort of activities that the people were engaged in at the time. A majority of the prints were left by young females who appear to have been occupied in gathering seafood from the beach, whereas the few male prints found appear to be connected to either hunting activities or animal management. At one site, a profusion of child footprints were discovered meandering all over the beach; a miraculously preserved snapshot of a moment in time, thousands of years ago, when a group of children spent a carefree, sunny day playing in the intertidal mud.

But it is not only human prints that have been preserved at Formby Point. Many different types of animal and bird tracks have also been identified and catalogued, ranging from wading birds, such as oystercatchers and cranes to larger animals, such as deer, horse, wild boar, large dogs and wolves. Of all the different types of animal prints that can be found at Formby, the most interesting belong to an extinct species of wild cattle called Aurochs. Standing around 6 feet high and measuring around 11 feet from nose to rump, Aurochs were

incredibly ferocious beasts. Despite their bulk, they were remarkably fast and agile. Their presence along the Neolithic shoreline of Formby must have made foraging trips to the beach rather hazardous. Sadly, the Aurochs were hunted into extinction in Britain by the end of the Bronze Age around 3,000 years ago.

In the late 1980s, the footprints came to the attention of retired teacher Gordon Roberts, who quickly realised their importance. So far he has devoted over twenty-five years to researching, recording and studying the footprints, in order to better understand the lives and times of the ancient people who once roamed around the Neolithic shorelines of Formby. He has also worked tirelessly to raise public awareness of the footprints, alerting visitors to the amazing prehistory hidden right beneath their feet.

How to find the footprints

The Formby footprints can be found along a 4-kilometre stretch of coast between Lifeboat Road and Gypsy Wood. The prints occur in sporadic outcrops of silt, which appear from time to time on the foreshore, approximately 100 metres (328 feet) west of the sand dunes. Finding the prints is not easy and it may take several visits before you find any at all. The areas where the prints occur are underwater for two hours either side of high tide, therefore it is essential to check the tide times to ensure that you pick the best time to search for the footprints. Please note that the tide rises quickly at Formby, so it is vital to keep a watchful eye on the sea level at all times, ensuring that you have a safe route back to the high water mark. It is advisable to wear stout waterproof boots, as the mud can be deep in parts.

For a safer and less muddy way of seeing examples of the footprints, you can visit the new Museum of Liverpool, situated on the waterfront at Pier Head. A replica of a footprint trail can be seen on the museum floor. This trail has been faithfully copied from plaster casts made by Gordon Roberts. Visitors can now literally walk in the footsteps of Liverpool's first inhabitants.

STANLAWE GRANGE

Stanlawe Grange, located near the southern end of Aigburth Hall Road, is the oldest existing structure in Liverpool. It was used mostly as a granary by the monks of Stanlawe Abbey. The first record of the building's existence can be found in the *Coucher Book of Whalley Abbey*, compiled in 1292. (A coucher book was a journal compiled by religious houses in order to preserve important documents, such as title deeds, rights and privileges, etc., to chronicle the order's history).

In the twelfth century, monasticism was on the rise. As a consequence, the wealth and power of the religious houses increased, mostly through donations of land from major land owners. Often, the donated land was located at a considerable distance from the recipient abbey. In order to make best use of these distant estates, the religious orders used outlying land to establish monastic farms, otherwise known as granges. Stanlawe Grange was no exception, run under the control of the Cistercian monks of Stanlaw Abbey, once located close to where the Stanlow oil refinery stands today.

Although it is undoubtedly the oldest structure in Liverpool, Stanlawe Grange has undergone a radical transformation over the centuries, with major alteration work taking place in the fifteenth, sixteenth, seventeenth and twentieth centuries.

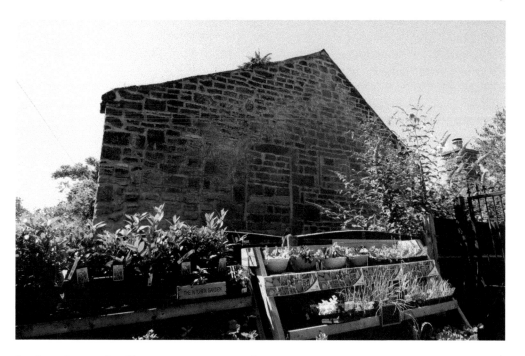

Stanlawe Grange: the oldest structure in Liverpool.

Constructed from large sandstone blocks, the walls are almost a metre thick (3 feet) in places. In the original construction no mortar was used, the stones instead being cemented together with red clay. The roof beams were constructed out of high grade oak that had been roughly shaped with an axe. The whole roof – its oaken plates, rafters and beams – were fastened together with oaken pegs rather than nails, giving further clues to the antiquity of the building. With so much quality oak used in the Grange's construction, it will be no surprise to learn that oak trees were extremely plentiful in the area in times past. In fact, the derivation of the area's name, 'Aigburth', is 'Ackebergh' or 'place of many oaks'.

Originally, the grange was comprised of a detached hall, monks' quarters, barns and a granary. However, only the granary and monks' quarters have survived into the present day. Although the current structure has been radically altered over the centuries, there are still a few clues in existence as to the building's antiquity.

The three-paned mullioned window to the immediate left-hand side of the property is one of the only external features to reveal the structure's true age. On the window's lintel there is a mason's mark in the shape of a double 'H'. Apparently, a very similar mason's mark can be found at Birkenhead Priory, which possibly indicates that the same mason worked on the construction of both buildings.

On the rear wall of the granary there are a couple of carved inscriptions, situated at the foot of the steps. These are thought to be the initials of two priests, who are believed to be buried nearby. Due to the dissolution of the monasteries during the reformation, the land was seized by the crown and eventually passed into the hands of the Tarleton family. The Tarletons were renowned recusants who refused to entertain the idea of following Anglican

(Church of England) practices. It is very possible that under Tarleton ownership, the grange could have been used for illegal Catholic masses. The penalty for this was severe. If caught, perpetrators were often put to death.

Although many people dismiss Stanlawe Grange as an old farm building, it is an important part of Liverpool's rich history. Its survival into the present day is truly remarkable considering the many changes the structure, and area, have undergone over the centuries.

THE ARCHER STONE

The Archer stone, which is located on the corner of Booker Avenue and Archerfield Road, is a prehistoric sandstone menhir (standing stone) dating back to the early Bronze Age (*c.* 2500 BC). Encircled by green iron railings, presumably for protection against vandalism, the stone has been situated here since 1928. The stone was originally located in a field approximately 150 metres (480 feet) away from its current spot, but was relocated to make way for a housing development.

The stone itself measures approximately 2.4 metres tall (7.5 feet) by 0.9 metres (3 feet) wide, and has a curious series of deep grooves running down one of its faces. Legend has it that the grooves were caused by people using the stone to sharpen their arrow heads, hence it becoming known locally as the Archer Stone or Robin Hood stone. There may be some truth to this legend, although its connection to Robin Hood and his merry men is

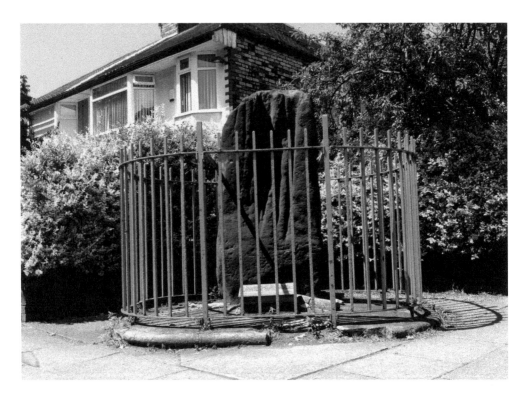

The Archer Stone.

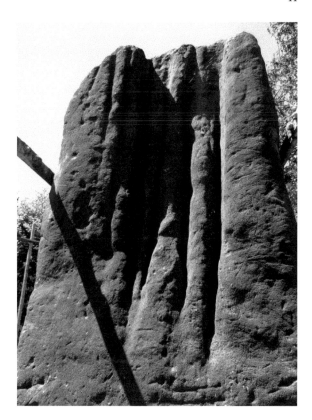

Close up of the grooves in the Archer Stone.

completely non-existent. During the reign of Henry VIII, an act of Parliament was passed in 1512, decreeing that every township had to make a field available for townspeople to practice their archery skills. The purpose of this was to maintain proficiency should a call to arms arise. Often, large stones would be strategically placed on these fields specifically for the purpose of sharpening arrows. Could the field that this menhir once occupied have been such a field, and could this be how both the Archer Stone and 'Archerfield Road' got their names? It is an intriguing theory, but it is equally possible that the grooves in the stone could have been caused by natural weathering; sandstone, being a very soft rock, is particularly vulnerable to erosion by the elements.

The grooves, however, are not the only markings to be found on the Archer Stone. In 1910 the stone was excavated and studied by archaeologists. On the buried portion of the rock they discovered several cup and ring markings, which look very similar to the markings found on the Calderstones (a collection of six mysterious sandstone rocks originally located in roughly the same area, which once formed part of the entrance passage of an early Bronze Age burial chamber). Due to the similarity in the carvings, it has been suggested that the Archer Stone could have been part of the same tomb.

Sadly, the cup and ring marks are no longer visible due to being submerged under a layer of concrete used to anchor the Archer Stone into position at its current location. However, it is fortunate that the historical importance of this remarkable menhir has been realised, and that steps have been taken to preserve it for future generations.

THE CALDERSTONES

The Calderstones are six roughly shaped sandstone megaliths, which date back to the late Neolithic period, around 2300 BC. The stones vary in height, ranging from 0.9 metres (three foot) to 2.4 metres (eight foot). Each is highly decorated with ancient petroglyphs, intricate carvings of spirals, concentric circles, arcs, cup marks, ring marks and footprints. They represent some of the oldest rock art found in the north west of England, and are arguably the most decorated megaliths so far discovered in mainland Britain.

Arranged in a rough circle within the confines of the Harthill Greenhouse vestibule, located on the western edge of Calderstones Park, these ancient stones hold some of the keys to unlocking the early history of Liverpool as a settlement.

Initially, it was believed that the stones once formed part of a stone circle. However, researchers are now confident that they were originally part of a Neolithic chambered tomb, more commonly known as a 'passage grave'. The passageways and inner chambers of such tombs were constructed out of large stones, which were then covered by a large mound of earth. It is presumed that the Calderstones themselves formed parts of the walls of either the passageway or the inner burial chamber deep within the mound itself.

The original location of the Calderstones tomb is not precisely known. However, most researchers are of the opinion that it was probably located fairly close to the current location. The first record of the stones' existence comes from a map drawn up in 1568 that was created

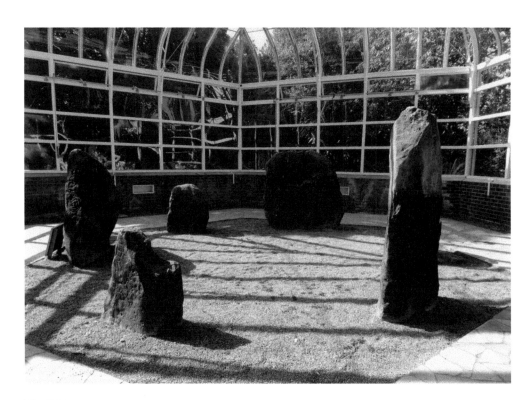

The Calderstones.

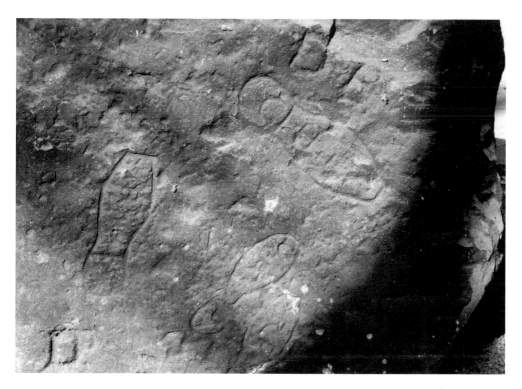

Nineteenth-century graffiti. Workers used to carve their shoe prints and initials onto the stones.

to help settle a border dispute between the fledgling townships of Allerton and Wavertree. At that time, the mound was still very much present and most of the stones lay buried deep within it.

At some point in time the mound was dug into to provide materials for local building work, at which point several coarse clay burial urns were unearthed and removed from the tomb. In the early 1800s, some of the stones from the interior lay flattened and exposed on the top of the remains of the mound, where they were used by local farm hands and gardeners to rest on during work breaks. According to accounts given by a man who grew up and worked in the area, it was common practice for workers to carve their initials and boot prints into the stones. Eventually, in the 1830s, the mound was completely destroyed and the stones unceremoniously dumped in a field, where they remained for many years.

In 1845, Joseph Need Walker – a wealthy lead shot manufacturer and owner of the estate that eventually become Calderstones Park – arranged to have a circular enclosure built outside the park's main entrance, in order to house the stones. Here they were stood upright in a circular formation, as it was presumed that this is how they had been originally arranged. They remained in the enclosure until 1954, when Liverpool Corporation examined the stones and found them to be in a very poor condition due to sustained exposure to the elements and industrial pollution. The stones were removed for cleaning and conservation. During this time latex moulds of the stones' surfaces were made in an attempt to preserve the markings and to reveal other markings that had become fainter over time.

Eventually, the stones were returned and put on display in the grounds of the park itself. However, without an enclosure to protect them, they became easy prey for a few young vandals who carved their initials onto them. During this time a vandal with the initials 'JL' left his mark on the stones. Local legend suggests that this could possibly have been the handiwork of a certain free-spirited youngster who would later find fame and fortune as a member of the greatest band of all time: The Beatles. It is an intriguing idea, but sadly one that is impossible to prove.

Because of the problems of weather erosion and the vulnerability of the stones to vandals, the decision was made to re-house the stones under cover. In 1964 the stones were relocated to the Harthill Greenhouse where they have remained ever since.

In 2008 the stones were studied and photographed by George Nash and Adam Stanford, who, using a technique they termed 'painting the rock', uncovered previously unseen markings on all of the stones. The technique involved shining a halogen light at an oblique angle to the stone surfaces and photographing the shadow detail cast by the markings. The study revealed that the markings on the stones were created in five distinct time periods: Neolithic, early to mid-Bronze Age, medieval, nineteenth century, and finally the twentieth century. Due to the presence of both Neolithic and Bronze Age art, it has been surmised that the tomb had been used for around 800 years by successive generations to house the remains of their dead.

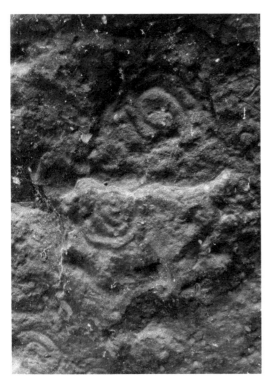 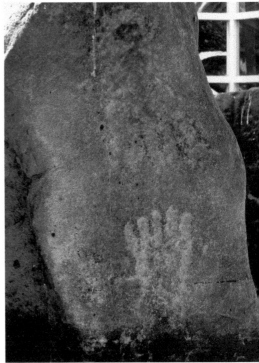

Above left: Neolithic spiral marks on the Calderstones.

Above right: Neolithic footprint carvings on the Calderstones.

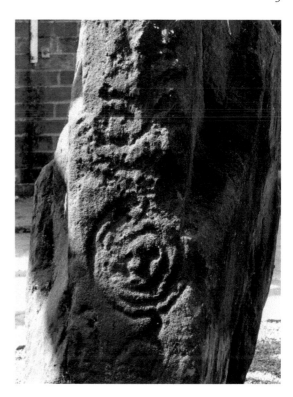

Bronze Age circular marks on the
Calderstones.

By comparing and contrasting the markings found on the Calderstones with other
Neolithic and Bronze Age sites across Britain and Europe, similarities can be found in the
style of the art that are indicative of cultural influences spreading out from Ireland to the
North West via north Wales.

One of the most interesting markings found on the stones is that of the footprints.
Although carved footprints have been found widely at sites across Scandinavia and Brittany,
very few have been found at Neolithic sites in the UK. In fact it is incredibly rare for footprint
markings to be found in association with Neolithic burial tombs at all. The closest example
to the footprints found on the Calderstones was discovered in a Neolithic tomb in Brittany,
making the Calderstones more historically and scientifically important.

The most intriguing carving discovered by Nash & Standford's analysis was of a stylised
dagger carved into the base of one of the stones. This dagger showed a marked similarity to
another found at a Bronze Age site in Galicia, north-western Spain.

At the moment, the stones are protected under lock and key, and are only viewable by
making appointments. It is hoped that, in the near future, the historically important
Calderstones will one day be made more accessible to the general public.

How to View the Stones
To request a viewing of the stones, simply call the Liverpool Direct Hotline on 0151 223 2008.
Your request will be forwarded to the park's Ranger Service, who will be happy to arrange a
convenient time for your visit.

THE ALLERTON OAK

Within the grounds of Calderstones Park stands another piece of Merseyside history, the Allerton Oak, the oldest tree in Liverpool. The tree's age is hinted at by its appearance. Its massive trunk is split down the middle and ancient heavy limbs are kept aloft by strong iron supports, giving the ancient oak the look of an elderly gentleman supporting himself with walking sticks. Within the split in the trunk, ferns have taken root and on the gnarled, moss-coated branches squirrels, birds and a myriad of insects have made the tree their home.

To the casual passer-by, the tree would appear to be in poor condition and require chopping down, but this tree is in the prime of its life and has many long years ahead of it. For compared to many ancient oak trees, this one would almost be considered a sapling.

Britain is believed to contain some of the oldest trees in Europe and the Allerton Oak is a prime example. Believed to be at least a thousand years old, the tree meets all the criteria the Woodland Trust say you should use for dating an ancient tree. Does it have a fat wide trunk? Yes. Is it squat or dumpy in appearance? Yes. Is it gnarled? Yes. Does it show signs of decay? Yes. Is it hollow inside? Yes. Are there roots above ground? Yes. Does it look in poor shape? Yes. If this oak is at least a thousand years old, it would have been seeded around 1013 or 1014, sometime during the reign of Æthelred the Unready, who sat on the throne between 979 and 1016.

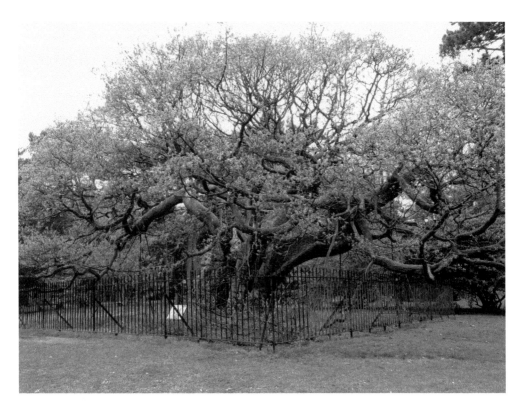

The Allerton Oak, oldest Tree in Liverpool – Calderstones Park.

To put the age of the tree into historical terms, the oak has lived through twelve royal houses and fifty-one kings and queens of England, including Richard the Lionheart, who fought in the Crusades; Henry VIII, who split from Rome to create the Church of England; the ill-fated Lady Jane Grey, who ruled for just nine days; Mary Queen of Scots; Elizabeth I right through to Queen Victoria and, finally, in our time, Elizabeth II.

The oak has also lived through the Viking invasion, Norman conquest in 1066, signing of the Magna Carta (1215) and English Civil War (1642–51), which led to Oliver Cromwell taking power before the House of Stuart was restored back to power (1660). The oak has also seen William Shakespeare (1564–1616) create all his masterpieces, the rise and fall of the British Empire and the American War of Independence (1775–83).

The oak has survived not just the early threat of being eaten by a wild animal or being chopped down for fire wood, but many storms, including the Great Storm of 1701, when hurricane-force winds hit the country, flattening many of the nation's trees and devastating cider production in the West Country for many years. The oak has also survived through two World Wars, in particular the carpet-bombing of Liverpool during the May Blitz in 1941.

The oak was already almost two hundred years old when Liverpool received its charter from King John on 28 August 1207, when Liverpool officially became a borough.

The oak is not only special because of its age; it is believed that the local 'hundred court' sat beneath its ancient branches. Here they would meet to discuss local issues and hold judicial trials. The courts ran until 1867, when they were replaced by the county courts, and although they no longer have any legal ruling, they have never formally been abolished.

The oak sits within the borough of Allerton and was part of the Allerton Estate owned from medieval times by the Latham family. Although the Latham family fought alongside Cromwell during the English Civil War, Cromwell confiscated the estate citing 'forfeiture in the name of treason'.

The estate was passed down or sold to several different owners, until a large swathe of land containing the oak was sold to settle debts, where it eventually it became known as Calderstones House and Estate.

In 1875, the estate was sold to Charles MacIver, who, along with Samuel Cunard, established the British and North American Royal Steam Packet Company (later known as the Cunard Line). MacIver passed the estate to his sons, who in 1902 sold it to Liverpool Corporation for the sum of £43,000, whereupon the estate became Calderstones Park.

Local legend has it that the Allerton Oak was split down the middle, not by age, bad weather or a lightning strike, but by the shockwave from a ship called the *Lottie Sleigh*, which exploded approximately 5 km (3 miles) away on the River Mersey on Friday 15 January 1864.

Moored on the river between Monks ferry and Woodside, the *Lottie Sleigh* was being prepared for a voyage to Rio Bento on the west coast of Africa. According to statements made by the crew, at around 5 p.m. that night, a steward was in the process of trimming the wick on an oil lamp when he inadvertently spilled lamp oil onto the floor. Somehow the oil ignited, and within seconds the decking caught fire. Despite the best efforts of all on board, the blaze spread to the cargo hold, where 11.5 tons of gunpowder was stowed. Fearing for their lives, the crew flagged down a passing steam ferry, the *Wasp*, which came alongside the *Lottie Sleigh* and evacuated all on board. Two hours later, the fire eventually reached the

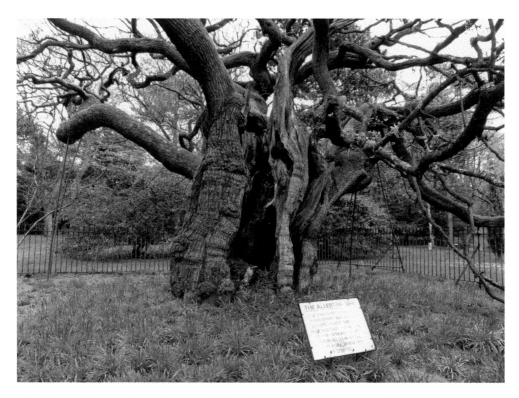

The Allerton Oak – torn in two by an exploding ship in 1864? Calderstones Park.

gunpowder and the ship exploded. The shockwave from the explosion shook most of the surrounding buildings to their very foundations and shattered the majority of the windows in the city. The shockwave also blew out most of the city's gas lamps in an instant, plunging the already terrified townsfolk into darkness.

The fireball from the explosion was described as looking like 'an immense meteor rushing upwards', which climbed to a great height before extinguishing itself mere instants after it had appeared. According to eyewitness accounts, the explosion could be seen up to 16 km (10 miles) away. The blast tore through the upper part of the ship, disintegrating much of what lay above the waterline. The hull of the vessel quickly sank and her bulwark and sides floated down the river on the tide. Spars, bolts and shredded decking were flung in all directions, with the flying debris narrowly missing onlookers on both sides of the river. A police officer and bystander, who were watching the incident unfold from a shelter near Salthouse Dock, had a very narrow escape when the force of the blast tore through a 3-inch-thick iron girder, sending fragments flying towards them. Luckily the pieces flew between them and they escaped unhurt.

At certain points around the city, the blast shattered windows and also blew doors off their hinges, buckled metal shutters and tore out entire window frames. The Town Hall clock was also a casualty of the blast; its face was blown inwards. On the outskirts of the city, many people ran out of their houses believing that an earthquake was occurring. In Toxteth Park a woman, who had a history of altercations with her next-door neighbours, battered their door

down and accused them of causing the commotion. As the pair slugged it out in the street, the police were summoned to intervene.

Although the waterfronts of both sides of the Mersey bore the brunt of the shock wave, damage occurred as far afield as St Helens and Runcorn. In both towns, doors were blown open and panes of glass shattered, while the ground shook as if it had been hit by an earth tremor. In fact, the sound of the explosion could be heard and felt up to 48 km (30 miles) away. When the sound reached Chester, the authorities telegraphed Liverpool to find out what had happened. By a sheer miracle, there was no loss of life that evening.

By another sheer miracle, not all of the *Lottie Sleigh* was destroyed during the explosion. The ship's figurehead, a carving of a beautiful young Victorian lady, was flung free of the blast and escaped serious damage. For a number of years, she was stored at a local ship breaker's yard, where she was eventually purchased by a gentleman from Rock Ferry. From Rock Ferry, the figurehead eventually ended up in a garden in Scotland, where she remained until eventually being purchased in 1927 by the Royal Insurance Company. She was then brought home and put on display in the reception hall of their Wirral training centre. Eventually, Royal Insurance donated the figurehead to the Merseyside Maritime Museum, where she is now on permanent display.

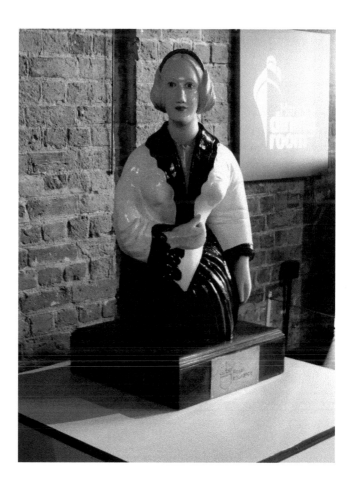

The figurehead from the *Lottie Sleigh,* which exploded on the Mersey in 1864 – Merseyside Maritime Museum.

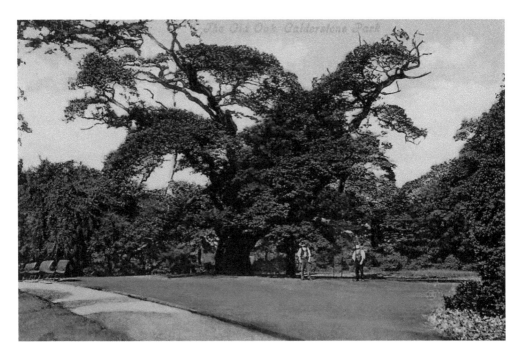

1904 picture postcard of the Allerton Oak.

But did the gunpowder explosion on the *Lottie Sleigh* *really* split apart the trunk of the mighty Allerton Oak as local legends suggest? In a picture, taken in 1904, the trunk of the Oak appears to be surprisingly intact and more compact than it is today. At first glance it would be easy to dismiss the *Lottie Sleigh* story as an urban myth, but on closer inspection, it is possible that the split in the trunk was hidden from the photographer's view due to the angle that the picture was taken from. Additionally, it is also possible that the explosion from the *Lottie Sleigh* only left a hairline fracture in the trunk which eventually split apart to the extent that can be seen today.

For the time being, the jury is still out on the connection between the *Lottie Sleigh* and the Allerton Oak. But no matter where the truth lies, it is very fitting that the last surviving piece of the *Lottie Sleigh* and the oldest tree in Liverpool are both made from the same material, and are both survivors in their own right.

2. Suburban Secrets

INTRODUCTION

In the suburbs surrounding the city centre are a few select gems, ranging from locations of interest to industrial archaeologists, such as the Ford Mushroom and Dingle Tunnel, to some of the finest public green spaces in the city, where rumour has it that a young Richard Starkey (Ringo Starr) lost his virginity and a rebellious John Lennon drew inspiration for one of the Beatles' most iconic works. Also in this section we will check out a Ghost Sign, see a semi-permanent mirage that appears over the city and visit the oldest dissenter chapel in the UK.

THE FORD MUSHROOM

On the outskirts of Liverpool, situated outside the Jaguar Car Body & Assembly plant in Halewood (formerly the Ford Factory), stands an impressive 45-metre tall (150-foot) landmark known locally as the 'Ford Mushroom'. Looking like something from a science fiction movie, this iconic structure is a water tower that stores water for the nearby car assembly plant.

Built in 1965 by the engineering firm Posford, Pavry & Partners, this concrete tower is based on a design first used in Sweden, which allows optimum storage space for water without taking up too much ground space below. The tower's 'saucer' has been elevated to a sufficient height in order to pressurise the water for use in the car assembly process.

Since its construction, its presence has produced a mixed reaction from the nearby community. For one, its unusual appearance has certainly put Halewood on the map, as the tower dominates the skyline of south Liverpool. On a clear day it can be clearly seen from as far away as the Cheshire plain or Welsh Hills. However, its sheer size has unfortunately played havoc with television reception in the tower's immediate vicinity. In one particular street, it was virtually impossible to pick up certain channels due to the tower blocking the signals from the nearby Winter Hill television transmitter. However, directly either side of the affected area, the television signals were strangely boosted by the tower reflecting signals from other, more distant, TV transmitters.

Many 'solutions' to the reception problem were suggested and tried by frustrated television engineers, but nothing really seemed to improve the situation. Fortunately, this unlucky 'electromagnetic shadow' effect was completely cured when the country fully switched over to digital transmissions in 2012.

Over the years, the tower has not only drawn the attention of frustrated television engineers, but also attracted the attention of paranormal investigators, some of whom seem convinced that the tower acts as a 'magnet' for visitors from another world. Between the late 1960s and early 2000s, there has been a steady stream of UFO sightings reported in the immediate vicinity of the tower. Reports have ranged from eerie glowing spheres of light hovering over the car plant, to strange silver, box-like objects that have allegedly been

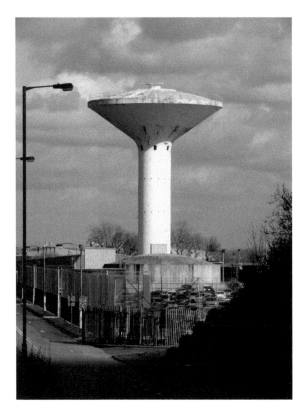

Left: Ford Mushroom in Halewood.

Below: Does this saucer shape act as a magnet for UFOs? Ford Mushroom in Halewood.

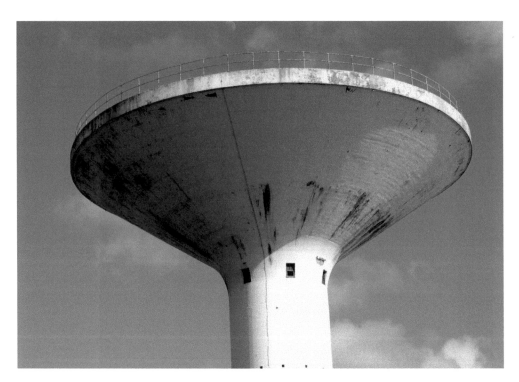

seen shining beams of light down onto the tower in the dead of night. Some people believe that these strange 'encounters' are caused by the overactive imaginations of people who are drawn in by the science fiction aspects of the tower's design. Others seem convinced that the tower has been constructed on an ancient ley line that naturally attracts paranormal activity. Whatever the truth of the matter, fact, fantasy or hoax, there have been no reports of unusual activity in the immediate area for over a decade.

Although the tower is not a listed building, it is certainly iconic, forming an important part of the landscape of modern Liverpool.

GARDEN DELIGHTS

Liverpool is surprisingly rich in green open spaces. Dotted around the city are numerous parks and gardens that provide a welcome retreat from the pressures of modern city life. Although the parks have been extensively written about in many local history books, there are a few quirky details that are often overlooked or only briefly covered by other works, which are worth looking at in more detail.

SEFTON PARK

Sefton Park is a 235-acre Grade II listed park located in south Liverpool. Originally forming part of King John's Royal Deer Park, the land was purchased by the City Council from Lord Sefton in 1867 for £250,000. The park was landscaped by celebrated landscape architect Edward André, and was eventually opened to the public in 1872. It boasts many attractions, such as a magnificent Grade II listed Palm House, boating lake and several delightful follies like 'Old Nick's Caves' and a 'fairy glen'.

One of the most interesting and overlooked features in the park is the Shaftesbury memorial and Eros fountain, located in the centre opposite the Aviary café.

The fountain is a replica of the famous landmark situated in Piccadilly Circus in the heart of London. Both were created by architect Sir Alfred Gilbert, as a memorial to Anthony Ashley Cooper, Seventh Earl of Shaftesbury. He was a politician, philanthropist and renowned social reformer, who improved the working conditions of factory workers and miners, amongst others.

The statue on top of the fountain was cast in aluminium, using the same moulds that cast the original in London. Aluminium was used to create both statues due to its lightness and strength, two factors critical in accommodating the Liverpool statue's very high centre of gravity, allowing it to lean over as far as it does without it snapping off at the ankle. The fountain was installed in the park in 1932.

Due to a combination of general wear and tear and vandalism, the statue was removed from the park in the early 1990s and taken to the museum's conservation centre. A replacement statue was returned to the park in September 2008.

Although the original in Piccadilly Circus and replica in Sefton Park are commonly known as Eros – the Greek god of love – the figure actually represents Eros' brother, Anteros (god of requited love). Gilbert deemed Anteros to be the most suitable classical figure to symbolise

the selfless philanthropic love that Lord Shaftesbury had for the poor. Sadly, the name Eros has firmly rooted itself into the public psyche, especially so for the monument in Piccadilly, which has come to be regarded as an iconic symbol of London.

Near the lake, sited on its own island, stands a Victorian bandstand rumoured to be the original inspiration for the Beatles song *Sergeant Pepper's Lonely Hearts Club Band*. Whether this is true or not is anybody's guess, but the bandstand would look very much at home on the cover of *Sergeant Peppers*. However, it is not the only piece of Beatle lore associated with Sefton Park. According to local legend, Sefton Park was the place where Richard Starkey (Ringo) lost his virginity on a field, behind the caravans of a travelling fair that visited the park, in 1957. In addition, it was also the place where the parents of Beatle-to-be George Harrison first met and fell in love. The story goes that Harold Harrison was walking along the path circling the lake, when he came across Louise French sitting on a bench. Louise made a disparaging remark about the hat that Harold was wearing, so he removed it and threw it in the lake. It was love at first sight; the rest is history.

The final semi-secret of Sefton Park lies just outside the magnificent Palm House. Amongst the amazing statures that ring the Grade II structure is a bronze copy of the famous Peter Pan statue (created by Sir George Frampton), which resides in Kensington Palace Gardens in

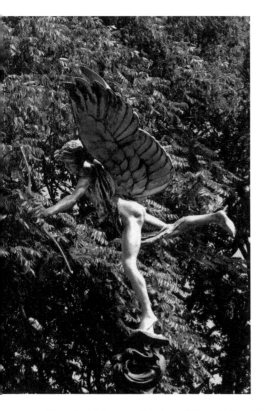 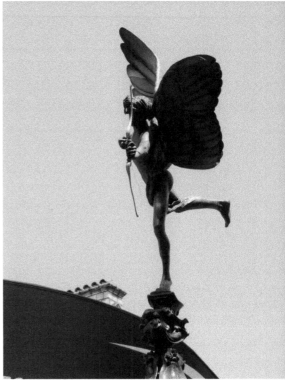

Above left: Anteros, brother of Eros, Sefton Park.

Above right: The Anteros statue in Piccadilly Circus, London.

London. In all, only seven copies of this statue have been cast from the original mould, and are now located all over the globe. The other copies can be found in Belgium, Newfoundland, United States, Australia and Canada. Liverpool's copy was commissioned and subsequently donated to the park by George Audley, the man also responsible for arranging for the copy of the Shaftesbury Memorial to be made and installed in Sefton Park. Peter Pan was unveiled on 16 June 1928. J. M. Barrie, the author of *Peter Pan*, marked the occasion by sending a telegram to the park addressed to 'Peter Pan, Sefton Park, Liverpool'. It read,

Behave today, if for the only time. Take care the Lord Mayor does not find you out. For heaven's sake don't grow when they remove your swathing sheet.

Among the assortment of faeries, squirrels, rabbits, frogs and other little creatures that adorn the statue, J. M. Barrie's signature can be found below Peter Pan's foot. It is a delightful tribute to the 'boy who would not grow up', and is a favourite of children, both young and old, who come to see it.

PRINCES PARK

Princes Park is another Grade II listed green space located just a stone's throw away from Sefton Park. It has been described by English Heritage as one of Liverpool's 'little gems'. The park was the brainchild of wealthy philanthropist; iron merchant Richard Vaughn Yates, who purchased 40 acres of land to create a much needed green space for the beleaguered district. Although the park was a private development, Yates's intention was to allow open access for the local residents. He enlisted the talents of Joseph Paxton, former head gardener of Chatsworth House, to design the park's layout. Paxton's design was hailed as an outstanding success and elements of it influenced the layouts of both Birkenhead Park and, years later, Sefton Park. Paxton later went on to design the Crystal Palace for the Great Exhibition of 1851.

Yates set aside the perimeter of the land to sell as housing plots. His intention was to use the money from the land sales to finance the park and pay for its upkeep. The park opened its gates to the public in 1842 and was eventually taken over by Liverpool Council in 1918.

Princes Park has some interesting features, such as its magnificent Sunburst Gates, located at the Princes Road entrance of the park. Designed by James Pennethorne, architect of the ballroom at Buckingham Palace, the gates are decorated with a radiating pattern of gilded spokes that represent the sun and its rays. The gates were removed for urgent restoration work, but were returned to the park in 2009.

Along one of the many paths that meander away from the park's lake, an unusual grave can be found. It is the final resting place of Judy, the park's resident donkey, who, for twenty-one years, gave children rides around the park. A commemorative headstone marks the spot where she was laid to rest. The inscription is now very faded, but with careful scrutiny the message can be read: 'In memory of Judy, a donkey who during 21 years service in this park was the children's friend. Died 12 August 1926'. Even today, floral tributes are left anonymously at the graveside in honour of this much loved creature.

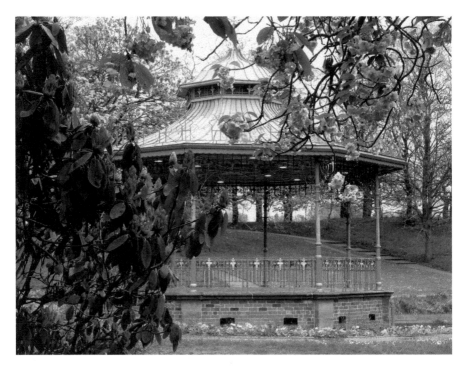

The Bandstand in Sefton Park, inspiration for the Beatles' *Sergeant Pepper* album?

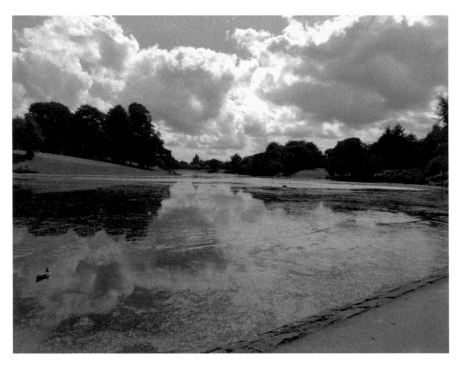

Sefton Park Lake, where George Harrison's parents first met and fell in love.

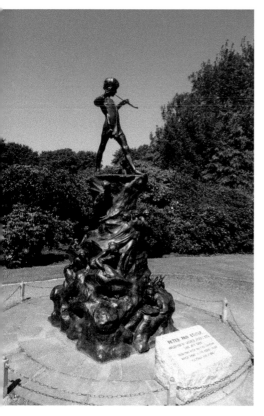

Above left: Peter Pan statue, Sefton Park.

Above right: Tinkerbell on Peter Pan statue at Sefton Park, now fully restored after thieves cut off her head.

At the Ullet Road end of the park, a 3-acre piece of mature woodland known as 'Park Nook' used to exist. This area was one of the last pieces of wild space left in the Toxteth district of the city, and as such, was a haven for all manner of wildlife, including forty species of bird, bat, fox and rabbit. Hidden in this nook were the remnants of an old nineteenth-century house, built by James Martineau, a priest and trusted friend of Joseph Williamson (the legendary 'Mole of Edge Hill', who employed out of work soldiers returning from the Napoleonic Wars to dig an extensive network of tunnels under Liverpool). Martineau, inspired by Williamson, arranged for the construction of tunnels under his Park Nook House for his children to play in. One of the tunnels was accessible via a hidden entrance in the Nook until around 2002. This tunnel ran for approximately 12 metres (40 feet) and showed signs of having once been linked up with others. The tunnel was solidly constructed from huge sandstone slabs and considered to be in excellent condition despite its age.

Unfortunately, in 2002 developers bulldozed the site to build houses there, destroying the tunnel in the process. However, according to correspondence written by Martineau, there are almost certainly other tunnels and possibly an underground grotto waiting to be rediscovered, hidden somewhere under the park.

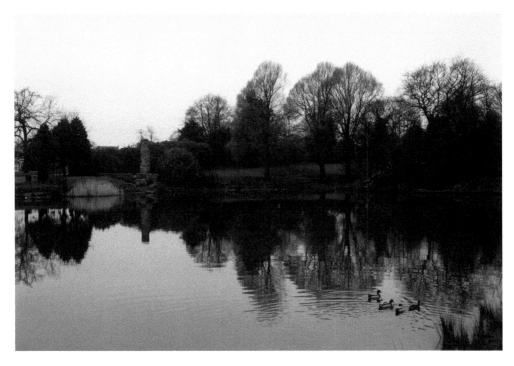

Princes Park Lake with the remains of an old boating house on the opposite bank.

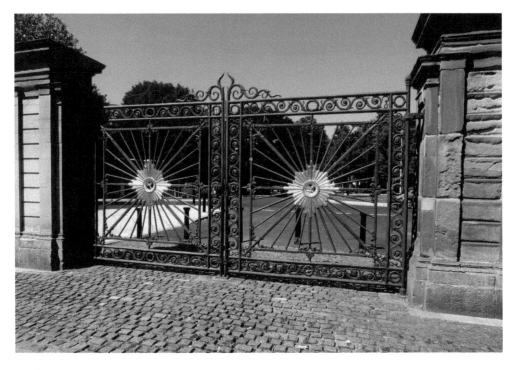

The beautiful Sun Gates, Princes Park.

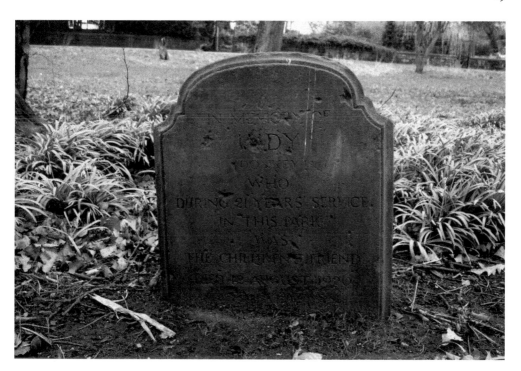

The grave of Judy the donkey, Princes Park.

FESTIVAL GARDENS

In the early 1980s, Liverpool was a city that had lost its way. The local economy was in tatters, unemployment was high and housing problems dogged the city. After the Toxteth Riots in 1981, the Merseyside Development Corporation was set up in an attempt to regenerate Liverpool and boost local morale. Their first project was to set up an international garden festival with the aim of boosting the local economy. With regeneration at the heart of the project, it was decided that a stretch of land in desperate need of redevelopment should be chosen.

The site elected was a 950,000-square-metre stretch of land situated just south of the old Herculaneum Dock in the Dingle, overlooking the Mersey. The land had previously been used as a landfill site for the city's rubbish.

The redevelopment took two years, 500 firms and thousands of local people to reclaim and turn the former rubbish tip into a beautiful park space. The festival opened its doors to the public on 2 May 1984 and ran for five months.

The International Garden Festival site was comprised of over sixty individual gardens, displaying a variety of designs and flora from around the world, the highlight of which was a Japanese garden complete with pagodas. The centrepiece of the site was the central exhibition space, a futuristic-looking, elongated dome constructed out of aluminium.

Other attractions included a walk of fame (a poor man's version of the Hollywood Walk of Fame) featuring around 100 celebrities connected with Liverpool, a light railway system, used to transport people around the huge site, and iconic sculptures, such as the Beatles'

Yellow Submarine, a statue of John Lennon and a Blue Peter ship. The festival was hailed as an outstanding success, attracting around 3.3 million visitors from all around the world.

After the festival closed, the site remained unused until the late 1980s, when it was purchased by a developer and reopened as Pleasure Island Amusement Park. This ran until 1996 and eventually closed due to the decline in the number of visitors to the attraction. The park was eventually abandoned and, over time, almost all traces of the former festival site disappeared; it became an overgrown mess. In 2006, half the site was sold to create a new housing development. The rest was recently restored to its former 1984 glory as a public garden space. Now called the Festival Gardens, it is well worth a visit.

Although almost all traces of the original International Garden Festival site have been erased from the landscape, there are still a few remaining artefacts that have miraculously survived.

Just down the road from St Michael's station, you can see a yellow stylised 'IGF' logo. These logos acted as markers on all the approach routes to the festival site to show visitors the direction to travel in. Although they were numerous in 1984, the example in St Michael's appears to be the last one in existence.

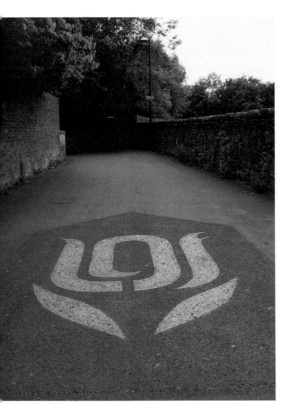

Above left: An International Garden Festival 'IGF' path logo. Possibly the last surviving example, close to St Michael's station, Aigburth.

Above right: Remains of a streetlight from the 1984 International Garden Festival, Otterspool Promenade.

Along the promenade, opposite the old garden site, you can find a stretch of railings that were put up especially for the festival. These all have an embossed 'IGF' logo moulded onto them about two thirds up.

The original festival car parks, specially constructed for the event, can also still be seen nestled into the rear of the current garden site. In the distance, deep in the undergrowth that rises above the car parks, several of the original lampposts, used to illuminate the footpaths that led to and from the festival's overflow car park, can be seen dotted here and there. Now minus their lighting globes, they look strangely eerie standing in the middle of nowhere.

These few remaining artefacts, reminders of a glorious summer festival that brought the city back from the edge of abyss in 1984, won't be here forever, so catch them while you can.

PARK ROAD AREA

BELVEDERE ROAD GHOST SIGN

Belvedere Road, on the corner of Pool Street

Ghost signs are the faded remains of old business signs or product slogans that were painted on walls, roofs or sides of buildings in bygone times. On most occasions the products or businesses are no longer in existence, making the ghost signs a valuable historical record of the past.

The ghost sign on a wall in Belvedere Road, however, is not for an advert or business sign, it is relic from the Liverpool Blitz. Between August 1940 and May 1941 Germany embarked on a heavy bombing campaign over Liverpool in an attempt to cripple the city's docks, which were absolutely vital to Britain's war effort.

The 'EWS' painted onto the wall of Belvidere road refers to an 'Emergency Water Supply', a storage tank set up to provide water for fire fighting and domestic use in the event of mains supplies being damaged or destroyed by bombing. EWS signs were stencilled on walls all around the city to give directions to the nearest emergency supply in the immediate vicinity. For Belvedere road the nearest supply was tank No. 77, located 200 yards south of the sign, but it is now unclear exactly where the tank was situated.

Although other EWS signs can still be seen scattered around the city, the sign at Belvedere Road is one of the best preserved. Other examples of EWS signs can be found in Bigham Road just off Sheil Road and Eberle Street off Dale Street.

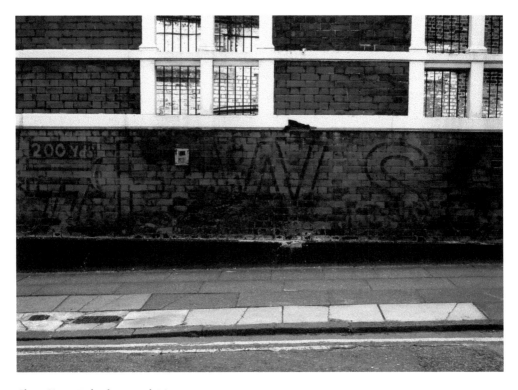

Ghost Sign – Belvedere Road, L8.

ANCIENT CHAPEL OF TOXTETH

At the corner of Park Road /Aigburth Road

The Toxteth Unitarian Chapel is located directly opposite the old Gaumont Cinema, at the bottom of Park Road. Built in 1618, this ancient stone building is the oldest dissenting place of worship in the UK. The land on which it stands originally formed part of Toxteth Park, a royal hunting ground owned by King John. Towards the end of the sixteenth century, the Crown sold the land to the Earl of Derby, who in turn sold it to Richard Molyneaux.

Molyneaux, being of Catholic faith, understood the harassment experienced by all non-conformist worshipers at that time, and so gave local Puritans permission to occupy part of his land in order to escape religious persecution. By 1611, around twenty families had settled there and established a small community.

First they built a schoolhouse and invited Richard Mather, former master of Winwick Grammar School, to become master of their new school. He accepted the post despite only being fifteen years of age at the time, and taught there for a number of years before going to Oxford to complete his own education. Later, he was invited back to the community to become the minister of their newly built chapel and performed his first sermon there on 30 November 1618. However, despite the best efforts of Molyneaux, the community experienced increasing pressure from the Church of England to conform, and so Mather decided to flee

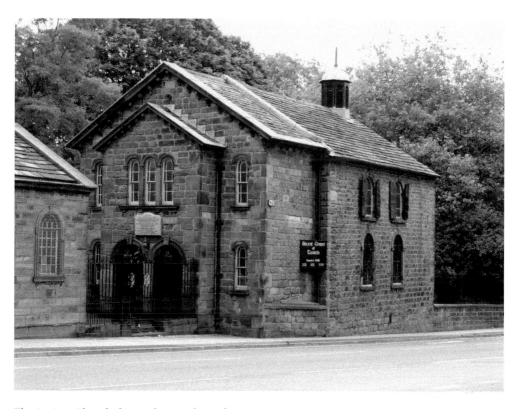

The Ancient Chapel of Toxteth on Park Road.

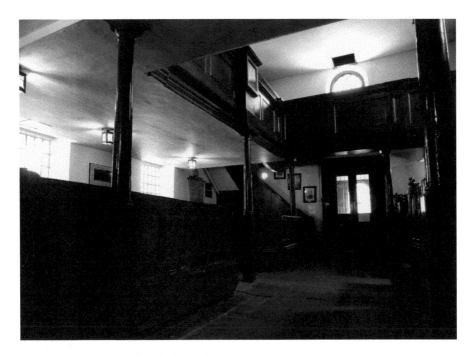

Interior of the Ancient Chapel of Toxteth.

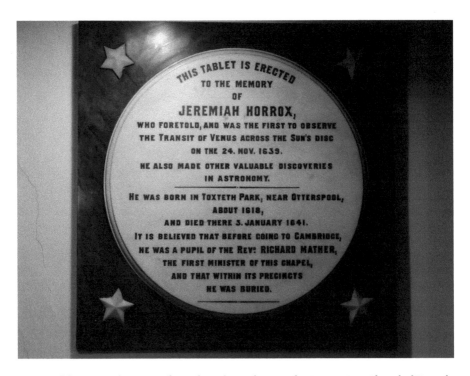

THIS TABLET IS ERECTED
TO THE MEMORY
OF
JEREMIAH HORROX,
WHO FORETOLD, AND WAS THE FIRST TO OBSERVE
THE TRANSIT OF VENUS ACROSS THE SUN'S DISC
ON THE 24. NOV. 1639.
HE ALSO MADE OTHER VALUABLE DISCOVERIES
IN ASTRONOMY.

HE WAS BORN IN TOXTETH PARK, NEAR OTTERSPOOL,
ABOUT 1618,
AND DIED THERE 3. JANUARY 1641.
IT IS BELIEVED THAT BEFORE GOING TO CAMBRIDGE,
HE WAS A PUPIL OF THE REV? RICHARD MATHER,
THE FIRST MINISTER OF THIS CHAPEL,
AND THAT WITHIN ITS PRECINCTS
HE WAS BURIED.

Memorial for Jeremiah Horrox, the Father of British Astrophysics, Ancient Chapel of Toxteth.

England and set sail for New England in 1635. He settled in Dorchester, Boston, preaching there until his death in 1669. His son and grandson went on to become presidents of Harvard and Yale Universities.

There have been a few notable people connected to the chapel and its community over the years. One such individual was Jeremiah Horrox, who made several important contributions to the science of astronomy. Born in 1619, Horrox made his first groundbreaking discovery at the age of sixteen. He demonstrated that the sun perturbed the moon's orbit around the earth, making it elliptical rather than circular as previously thought. Horrox's work predated Sir Isaac Newton's theories of universal motion, and Newton duly acknowledged Horrox as being instrumental in helping him to formulate his own theories of lunar motion. But this was not Horrox's only contribution to astronomy, for he was also the first person to accurately predict and see the transit of Venus across the face of the sun, on 24 November 1639. Horrox returned to Toxteth in 1640, where he began work on the study of the tides in relation to the movement of the moon. However, he sadly died aged twenty-two on 3 January 1641 before he could complete the work. Horrox's discoveries and achievements in astronomy have led to him being called the 'Father of British Astrophysics'. A commemorative plaque is mounted on the chapel wall in his honour. It is believed that he is buried either in the chapel itself or in its immediate vicinity.

Other notable people connected with the chapel include the Holt and Rathbone families, and the ancestors of Jazz singer George Melly. The Holts are famous for revolutionising the shipping industry with a fleet of steam ships known as the Blue Funnel Line, and the Rathbones were responsible for establishing a training college for district nurses in Upper Parliament Street, with the help of Florence Nightingale. The Mellys were known for their philanthropic deeds, including the provision of drinking fountains across the city, to give the poor access to clean water. Members of all three families are buried in the chapel's graveyard.

Inside the chapel are an array of amazing features, ranging from the elevated wooden pulpit surrounded by box pews, to the headstones of old graves that line part of the stone floor. On the door of the box pew to the left hand side of the pulpit can be found the initials D. M., along with the date 1650. This is the pew of the Mather family; the initials belong to Daniel Mather (no relation to Richard, the chapel's first minister). The hinges on this door are original and highly stylised, making them very rare indeed.

Originally, the interior of the chapel would have been rather austere, in keeping with Puritan values. The congregation would have sat on plain benches and the walls and pulpit would have been devoid of decoration. However, over the years, family pews have been installed, and the walls filled with commemorative stone and brass plaques that each contain snippets of the chapel's long history. On the wall opposite the pulpit can be seen an ornate clock that was installed in the chapel in the 1780s, made by William Lassell, a prominent member of the congregation.

Upstairs in the gallery can be found more box pews. The north and south galleries date from the seventeenth century and the gallery connecting the two was added in the eighteenth century. There is also an organ loft containing a magnificent pipe organ, made in 1906 by Brindley & Foster.

Outside in the graveyard, the most striking feature is a mid-nineteenth century classical arcade or colybarium, where the graves of the wealthiest members of the congregation can be found. There is certainly a lot to see and discover both inside and outside this incredible

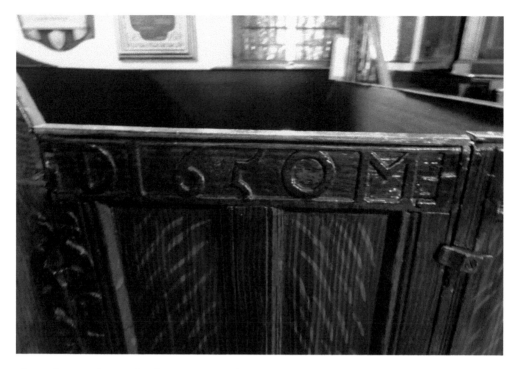

The Mather Family Pew, dated 1650, Ancient Chapel of Toxteth.

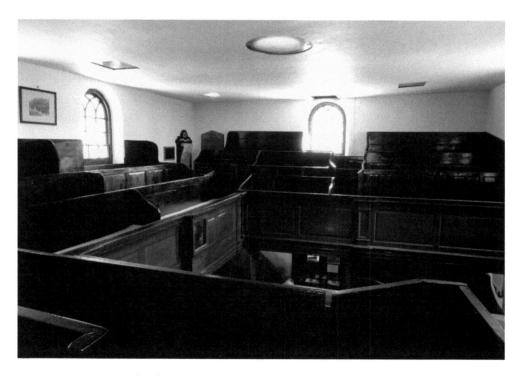

Upstairs Pews, Ancient Chapel of Toxteth.

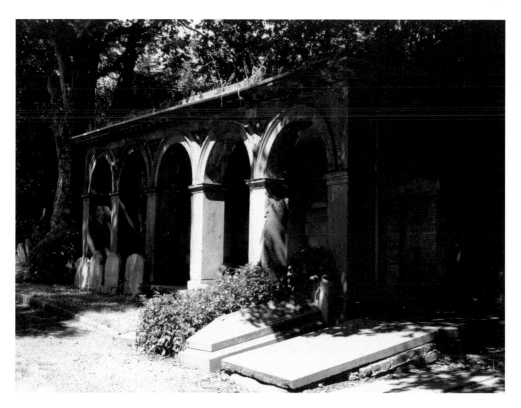

The Colybarium, Ancient Chapel of Toxteth.

chapel. When visiting, do not be surprised if several hours pass by in the blink of an eye as you take in the amazing amount of history contained within these ancient walls.

How to visit the Chapel
Visits to the chapel can only be made by prior appointment. Call a member of the chapel's committee on 0151 263 4899 to arrange a mutually suitable date and time to visit.

THE DINGLE TUNNEL

Kedleston Street, just of Park Road L8
Just off Park Road, in the Dingle, lies Kedleston Street. This street is like most streets in Liverpool in one respect; it has a row of terraced houses lining each side of the road. However, unlike most streets, this one contains a part of Liverpool's lost transport history.

As you enter the street from the Park Road end, to your right is the concealed entrance to a motor repair garage, situated behind a rusty gate. This building has been used as a garage since the early 1970s, prior to that it was used for the manufacturing of ropes. But neither of these functions is in keeping with the building's original purpose, as the Dingle terminus for the Liverpool Overhead Railway.

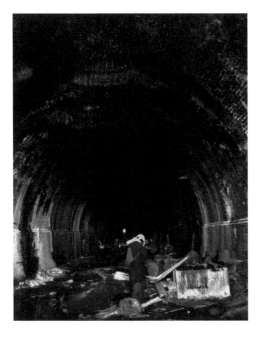 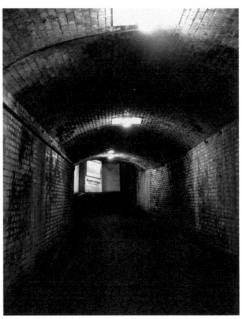

Above left: Looking down the Dingle Tunnel from the Herculaneum Dock exit.

Above right: Subway leading to the Dingle Tunnel station.

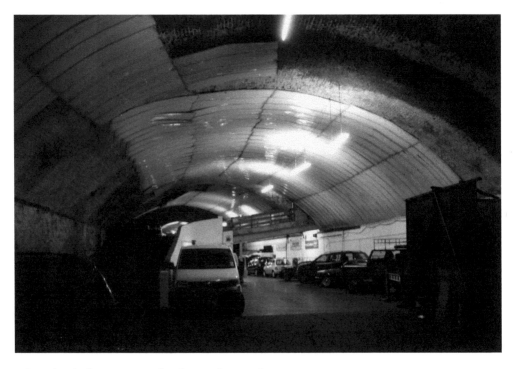

Where the platform once stood in the Dingle Tunnel.

Opened for business in 1893, the Liverpool Overhead Railway (LOR) was a 10.4-kilometres-long (6.5-miles) elevated rail line, which ran from the Dingle to Seaforth. Since this line ran adjacent to the Liverpool dock line, and due to its elevated track way, it was frequently used by workers to shelter under in inclement weather, which earned it the local title of the 'Dockers' Umbrella'. The trains on the LOR were not powered by steam, but by electricity. This was extremely pioneering for its time and many other countries, including America, modelled some of their own railways along the same lines.

The LOR was originally built to end at Herculaneum Dock, but residents within the suburbs complained that this was not convenient for them. In 1897, the LOR was extended underground into the Dingle, with plans for further extensions to be made in the future. Unfortunately these extensions never occurred and, throughout its life, the eastern end of the Dingle tunnel has remained as an unfinished expanse of exposed sandstone. The Dingle station and tunnel were the only underground sections of an otherwise elevated railway line.

The tunnel itself is just under 1 kilometre (0.5 miles) long, ending at a single platformed station. The width of the tunnel is just over 7 metres (25 feet), with a height of 5.7 metres (19 feet). This ran for roughly 554 metres (186 feet), before widening to 17.3 metres (52 feet), with a height of 7.62 metres (25 feet) at the station. The tunnel was regarded as being an amazing engineering feat, as no tunnel arch had previously been constructed to this scale. Once in the station section, the railway track split into two and ran either side of the central platform island, before merging and eventually terminating at the point where the ill-fated extension was planned.

Passengers entered the station via the booking office situated above ground on Park Road. It was a three-storey building with a canopy, extending out from the first storey to cover the street below. The ground floor was the booking office and entry point to the station; the second and third floors were used as offices. Unfortunately, nothing remains of the above ground station today.

Entry to the station from the booking office was via a subway that snaked downwards and ended at a small steel bridge with steps leading down onto the platform. The subway, bridge and steps had a barrier running down the centre, which separated incoming and outgoing passengers. The platform itself was empty except for the ticket collector's hut and a few sheltered seats. The subway and bridge are still present in the garage space, and remain largely unchanged from the days of the LOR.

Station Fire

The LOR service was by all accounts incredibly reliable, with a largely unblemished safety record until tragedy struck in the early evening on 23 December 1901. On that fateful evening, a train coming into the station caught fire and the subsequent blaze killed six people in the station.

A board of enquiry was set up to find out what had gone wrong. Their findings were detailed in an extensive report issued to the board of LOR. Details of the accident were as follows: the 5 p.m. train from Seaforth sands was running around six minutes late, due to a defect that had occurred in the rear motor, when it came to a complete standstill just 80 yards (73 m) out of the Dingle station. The fire started when the driver attempted to manually restart the motor.

There were a total of twenty-nine passengers on the train. The guard, Charles Maloney, and the driver, Robert Ashbee, urged the passengers to stay in their seats; they believed they

could put out the fire themselves. However, the flames quickly spread through the wooden carriages, assisted by the vigorous back draft that was always present in the tunnel. Quickly realising that they were fighting a losing battle, the driver and conductor evacuated the passengers and moved them to safety further up the platform. The majority of the passengers left the station and made their way home, but two passengers decided to stay on the platform to watch the fire.

The station foreman Thomas Rendell and car cleaner J. C. O'Brien returned to the train, along with the guard and driver, attempting to put the fire out, but again failing. Within ten minutes of the fire starting, Thomas Rendell called up to the ticket office and asked the booking clerk to send a telephonic message to the generating station, requesting them to cut the power. Rendell himself sent a similar message to the railway company. Once the message was received, the power was cut to both rails and station. This, however, achieved nothing except plunging the station into darkness.

Within twelve minutes the train was fully ablaze and the station filled with smoke. The back draft pushed the smoke up the stairs, along the subway and out through the booking hall. Although the train had come to a standstill 80 yards from the station, the mixture of heat and gases had turned the tunnel into an inferno, making it impossible for the attending firemen to enter.

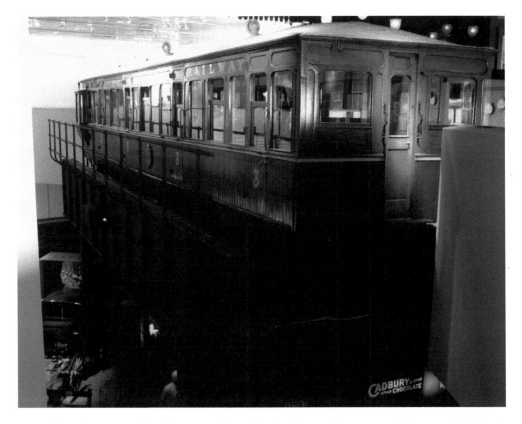

Original wooden carriage from the Liverpool Overhead Railway at the Museum of Liverpool, Pier Head.

The last people known to have left the station alive were Signalman Owen, a boy called Gough and a Mr Stewart. Gough was credited with helping passengers escape before being overcome by smoke and collapsing unconscious in the booking hall.

What happened in the tunnel and station after they left can only be speculated, but it is believed that Rendell guided the two remaining passengers, Messrs Beadon and Bingham, to the foot of the air shaft, which was situated in the eastern end. Perhaps they were under the illusion that they would be able to breathe easier under the air vent. However, the vent acted as a flue and rapidly filled with smoke and fumes. Their bodies were found at the foot of the shaft.

Ashbee must have continued to attempt to put the fire out, as his body was found next to the train. Maloney had made it as far as the platform before he passed out and O'Brien was found on the western end of the platform, next to the hydrant.

The report concluded that Robert Ashbee, the driver, had been to blame for the events; he had not complied with the company procedure of disconnecting the faulty engine and running on the spare. It was concluded that an electrical arc had caused a rush of current and an opened circuit breaker had caused the train to stop. Ashbee's repeated attempts to restart the engine caused a 'flash' to occur, setting fire to the woodwork on the coach. Charles Maloney was also criticised for showing a lack of judgement by allowing the two passengers to linger on the platform.

The report recommended that woodwork should no longer be used in the construction of electric locomotives, articulating that station platforms should be made of stone or concrete, signal boxes from brick or iron. All the recommendations in the report were actioned by Liverpool Overhead Railway Company.

The LOR continued to run for many years, surviving the war and bombings. In 1955, it commissioned a survey of the railway, showing that within five years the iron structures that supported the line would need at least £2 million worth of repairs. Unfortunately the company did not have that kind of money, and they were unable to find anybody willing to foot the bill. On 13 December 1956, the LOR closed for good. Demolition of the structures and rails began in September the following year, and by 1958, almost all traces of it were gone.

Within the tunnel, all traces of the railway were removed and a rope manufactures moved onto the premises. Later, the tunnel was used as a motor repair garage. On street level, the booking office was levelled; although another building was constructed in its place, it now lies empty.

The subway remained untouched, but a concrete bridge and ramp were added to allow cars easy access down into the tunnel. In 1977 the current occupiers, Roscoe Motor Repairs Ltd, moved in.

Visit to the Tunnel

Fortunately, the tunnel was not closed off completely to the public; we were able to gain access to it in 2012 by attending a ghost hunt event run by Night Vision Investigations. From the moment I first heard about the tunnel, I wanted to go inside and see it for myself, so when the opportunity arose, I jumped at it immediately.

Filled with excitement as I walked down the subway, still lined with original tiles, I entered across the bridge and down the ramp into what had once been the station.

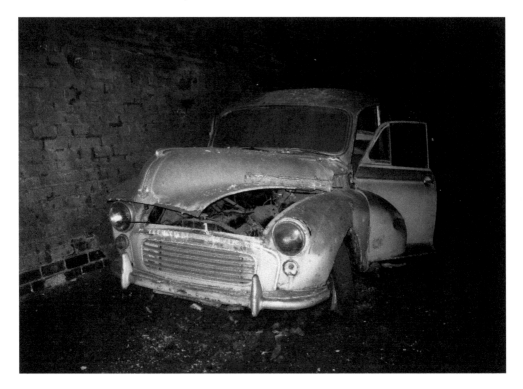

One of the old cars stored in the Dingle Tunnel.

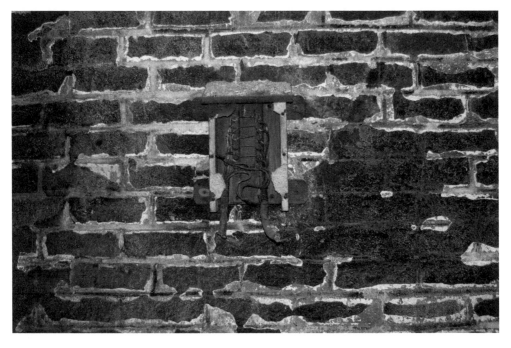

Remains of an old junction box on the wall of the Dingle Tunnel.

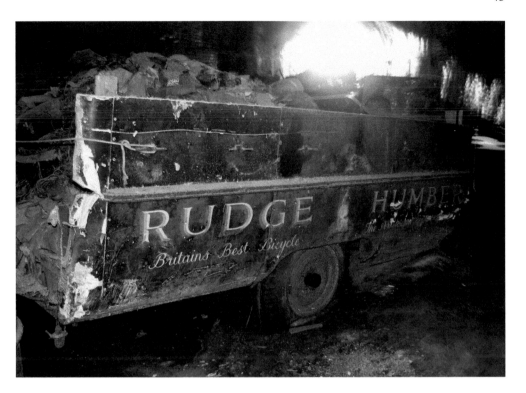

Old trailer in the Dingle Tunnel.

Plastic panels and florescent lights hung from the brick arched roof, and concrete lined the floor. The station end had been completely converted into a working garage and an office was now situated where the air vent had been.

Looking down towards the tunnel, rows of old tyres and vehicles jammed the entrance. Beyond was nothing but blackness. Switching on our torches, we moved away from the glaring lights of the garage and into the tunnel itself. I had been told that the tunnel had been used to store old abandoned vehicles, now I was seeing it for myself. A few feet into the darkness I came across an old, abandoned truck. By its style, I estimated that it dated back to the 1950s or 1960s. Next, I came across a collection of cars covered in decades' worth of dust and dirt. Some of them looked like they had been stripped of anything useful; others looked like they could have been driven home. But cars were not the only things that had been abandoned in the tunnel. Metal staircases, an old trailer filled with rubble and an old boat lay abandoned in the gloom, patiently waiting for their owners to return. There were also office desks and pieces of broken equipment, tyres propped against the wall and mounds of old rope lying discarded from the rope making business decades ago. It was a veritable time capsule, a snapshot of the working life of the tunnel since abandonment by the LOR.

Not all traces of the LOR have been erased from the tunnel, however. High up on the tunnel wall were railway signals, electrical junction boxes, and lengths of electric cable. On the floor were dozens of fastening pins for the old trackway, discarded after the rails were ripped up. The place was an industrial archaeologist's dream.

After walking a considerable distance, a far-away pinprick of light appeared; we had almost reached the Herculaneum entrance of the tunnel. The debris had thinned to almost nothing at this point, with just a few planks of wood and bundles of rope littering the floor. Large pools of water filled this end of the tunnel and I almost wished I had brought an umbrella, as the water poured in through the ceiling from the ground above.

As I walked through the tunnel, I was clicking away with my camera. I wanted to document everything I was seeing, from the abandoned cars to the bricks still blackened from the fire all those years ago. My camera, which I had only purchased a few weeks before, had been working perfectly ... until I tried to take a picture of a blackened alcove. First the flash failed to fire, then when it did work the picture turned out completely black, which was strange; the flash had a 15 mile radius. It took me another five or six attempts to take the picture, and once I moved on from that spot my camera worked perfectly again. It was only later, when I returned home and began to research the tunnel, that I realised that the spot was where the fire had started, and where Robert Ashbee had died. Spooky coincidence?

On 24 July 2012, mere weeks after I had been in the tunnel, I heard the terrible news that part of it had collapsed. Fortunately no one was hurt, but as a precaution the police closed down the bottom end of Park Road, evacuating several families out of fear of further collapse.

Part of the roof at the station end of the tunnel had collapsed into the garage below. A survey of the damage was made and it was found that parts of the tunnel were incredibly unsafe. Although roads in the area above the tunnel were re-opened, and most of the residents allowed back in their homes, residents from eleven properties that lay directly above the tunnel were not allowed back. To the dismay of these residents, it took the council and insurance companies eighteen months to come to an agreement over payments for repairs to the tunnel. Once these repairs had been carried out, the residents were allowed to return home, but sadly the tunnel is now closed forever.

THE PARK ROAD MIRAGE

At the highest point on Park Road just after the Tesco 24 Hour Store
If you head down Park Road, travelling towards the city centre, take a look at the horizon. As you reach the highest point of the road, a short distance after passing the Tesco Superstore, you can often see the upper halves of wind turbines gently spinning in the breeze above the city skyline. To the casual observer they look perfectly normal and appear to be relatively close. However, it may surprise you to learn that these turbines are located almost 7 kilometres away (4.3 miles) at the Alexandra and Huskisson Docks. Although they are clearly visible from this vantage point, once you reach the city centre they cannot be seen at all, despite being 125 metres (410 feet) tall. To fully illustrate that what you are seeing is very odd, if you keep your eye on the turbines as you head away from the city centre you will actually see them grow in height the further away you travel.

What you are seeing is an effect called a towering superior mirage. This particular mirage occurs when there is layer of cool air near ground level, with a warmer layer of air directly above it. This causes light to refract (bend) as it passes through the different layers. It can make objects appear much taller, larger or closer than they actually are. This effect typically

Right: Mirage of the wind turbines, as seen from Park Road.

Below: Mirage of the wind turbines in Liverpool Bay, seen from Crosby Beach.

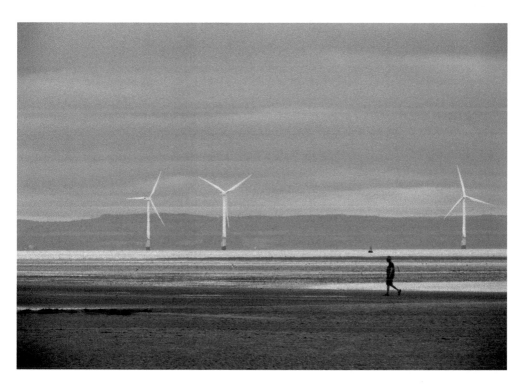

occurs over cold bodies of water, especially in the Arctic and Antarctic. Although the effect can't be seen all of the time, it is present for most of the year. This effect can be seen from a number of vantage points on both sides of the river when looking out in the general direction of Liverpool bay. The effect can be particularly dramatic when seen from Morton on the Wirral, or Crosby and Formby beaches, but this time it is a mirage of the turbines from the Burbo Bank Wind Farm (located far out in Liverpool bay). This effect has only been particularly noticeable since the building of the wind farms, but the conditions for creating superior mirages have always been present over Merseyside.

One of the most famous occurrences of a mirage seen over the area occurred on 27 September 1846. Two Wirral residents saw an image of Edinburgh projected onto clouds over Liverpool whilst visiting Birkenhead Park. The image persisted for around forty minutes. It appears that what they saw was not an image of Edinburgh, which lies over 353 kilometres (221 miles) away, but an image of a panoramic model of Edinburgh that was on display in the Zoological Gardens in Liverpool. In recent years, several local people have reported seeing ghost-like ships sailing tens of metres above the surface of the river.

Although the effect can be seen at ground level from Park Road, the best way to view the phenomenon is to catch a No. 82 double-decker bus heading into the city centre, and sit on the front seats on the upper deck. The effect is particularly marked from around mid-morning onwards; it is visible in both sunny and overcast conditions. On some occasions the effect is very unmistakable with the turbines dominating the skyline, but on others they are barely visible save for the upper tips of their blades.

ELDON GROVE

Located off Vauxhall Road, Liverpool L3

Standing as a lone testament to Liverpool's proud commitment to social equality, the three blocks of Eldon Grove, opened by Liverpool City Council in 1912, silently await their demise. Even today, shuttered off from the world by almost impenetrable steel barriers erected by the demolition teams, the impressive structures still command your attention when glimpsed fleetingly through the odd gap, despite their advanced state of decay and dereliction.

Back in the day, Eldon Grove was a thriving and vibrant community, a place where you didn't merely exist, but lived with a sense of pride and purpose. The buildings were originally built as labourers' accommodation, and boasted a luxury that would normally have been beyond the means, and wildest dreams, of the working class occupants. Not only did the properties have hot water on tap, they also had baths and interior flushing toilets – welcome features for weary dockworkers returning home from gruelling fourteen-hour shifts.

There is something very special about Eldon Grove that defies explanation; a feeling of magic pervades the air like a delicate fragrance. One can't fail to be moved by the place, from the mock Tudor exteriors atop of the Art Deco structure, to the remains of two 1914 gas lamps that grace the front communal garden. Half-close your eyes and you could almost believe that you have been transported back to the start of the twentieth century.

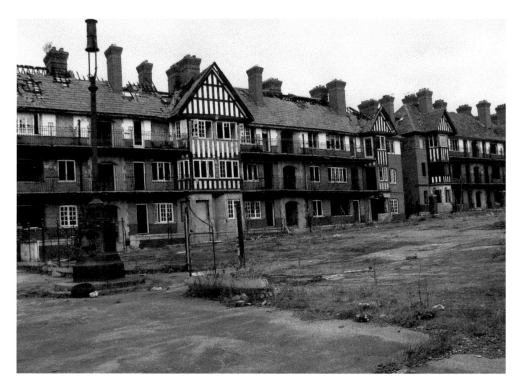

1912 Social Housing, Eldon Grove, L21.

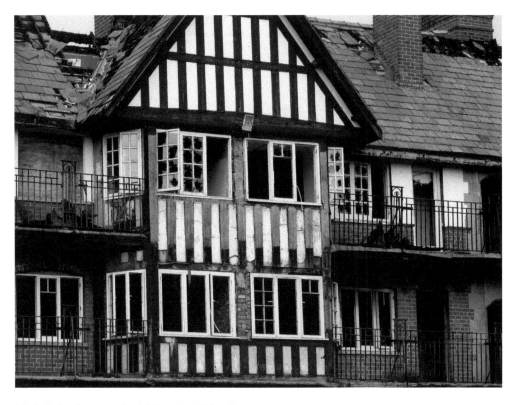

Mock Tudor fronts on Social Housing, Eldon Grove.

But it's not just the buildings that make this area so special, for one of Eldon Grove's best kept secrets dates back almost twenty-five years before the construction of the 1912 accommodation. Eldon Grove was the birthplace of one of Liverpool's forgotten musical heroes, William Gordon Masters, who was born in 1887. William, born to Irish and Jamaican parents, started his musical career as a singer/dancer with The Lancashire Lads, an ensemble that also boasted Charlie Chaplin amongst its ranks. From there, William became involved with the exciting new Jazz movement, wowing high society audiences in London and also playing in West End shows. Somewhere along the line, William changed his name to Gordon Stretton and took a jazz ensemble called The Syncopated Six out to France, taking Paris by storm. He was a true innovator, a Jazz pioneer, and one of the first jazz artists to record on early discs. He was one of the first Liverpool-based musicians to gain international success, a remarkable feat, especially considering his humble origins. William finally relocated to Argentina in 1929, where he remained working with his symphonic jazz band until his death in 1982. It is so sad that this remarkably talented individual is hardly known at all in his hometown, but maybe one day he will receive the recognition that he so rightly deserves, and take his place alongside the musical giants of Liverpool.

Until then, Eldon Grove will remain, for a while at least, as a silent testament to social equality and freedom of expression, where the dreams and aspirations of generations of Liverpudlians were not met with derision, but with optimism and encouragement.

3. City Centre Wonders

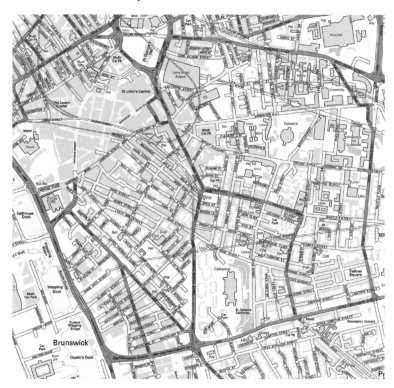

INTRODUCTION

Liverpool City Centre is an amazing location to explore. It is rich in architectural diversity, containing magnificent buildings from almost all periods of the city's 800-year history. In some streets, Victorian, Georgian, Gothic and Art Deco buildings stand cheek to jowl, all vying for attention. In this section we look at a mixed bag of places and artefacts, including the telephone box inside Liverpool Cathedral, a shell covered boat that has sat in the window of an abandoned shop for over thirty years, music clubs that put Liverpool on the world map and an old fruit warehouse that became the creative heart of the city, plus much more.

ǀ

LIVERPOOL ANGLICAN CATHEDRAL – OF MICE, MEN AND TELEPHONE BOXES

On top of St James' Mount (close to the city centre), stands the instantly recognisable and utterly majestic Liverpool Anglican Cathedral. With a length of 188.7 metres (619 feet), a height of 100.8 metres (331 feet) and floor area of 9,687 square metres (104,274 square feet), it is the largest cathedral in the UK and fifth largest in the world. Constructed out of local pink sandstone, this

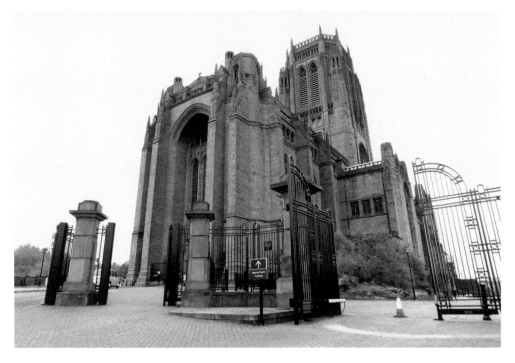

Liverpool Anglican Cathedral.

impressive structure took seventy-four years to complete. It also boasts some world-record-setting features: the largest gothic arches and vaults ever built, highest bell tower (at 66.75 metres or 219 feet) and heaviest set of ringing bells (weighing 15,241 kg or 16.8 tons) in the world, plus the UK's largest pipe organ – bigger even than the one installed in the Royal Albert Hall. Built by Henry Willis & Sons at a staggering cost of £3 million, this organ boasts 145 stops and nearly 10,000 pipes. All in all, the scale of this building and its contents is truly monumental.

The Anglican Cathedral was designed by Sir Giles Gilbert Scott, who gained the commission via a 1901 competition to find a suitable design for the proposed new Anglican Cathedral – only the third to be commissioned in the UK since the Reformation in the sixteenth century. Since it was one of the biggest building projects in its day, it attracted a considerable amount of interest. At the time, Scott was a twenty-two-year-old apprentice working for architect Temple Moore. Although Moore had entered the competition himself, he encouraged Scott to do likewise. To Scott's amazement, his design was chosen over all other entries, despite the fact that he was a Roman Catholic and had no building designs to his credit. In fact, his only major work at that time was a design for a pipe rack.

Work began shortly after Scott's appointment, with the foundation stone being laid by Edward VII on 19 July 1904. When the stone was laid, political literature of the day was buried underneath it for future generations to discover.

Work progressed steadily until the outbreak of the First World War, when construction work almost ground to a halt due to a severe lack of labour. During the Second World War, work was actually set back because of damage caused to the structure by German bombing

in the Liverpool Blitz. Scott continued on the project until his untimely death in 1960. The cathedral was finally completed in October 1978.

Although the cathedral was undoubtedly Scott's grandest achievement, he also created other celebrated works in his lifetime. For instance, he was responsible for the designs of Waterloo Bridge and Battersea Power Station, both now iconic London landmarks. However, his most famous and ubiquitous designs were not for buildings, but for public telephone boxes.

In 1924, Scott was invited to enter a competition set by the General Post Office (GPO) to come up with a design for a new generation of phone boxes. Scott's design was a winner due to its classical style and advanced functionality. The design was called Kiosk No. 2 or K2 by the Post Office, who later put them into production and installed them all over London. The design was an instant hit.

At the time of the competition, Scott was a trustee of the John Soane Museum. When designing the K2, he drew inspiration for the top of the kiosk from the dome on top of the mausoleum that Soane had designed for himself in St Pancras churchyard. In addition, some say that the body of the K2 bears more than a passing resemblance to the central tower of Liverpool Cathedral, almost as if Scott had 'plundered' aspects of his cathedral design to create the iconic K2 shape. If this is true, then both the cathedral and the phone box had 'communication' at the heart of their designs. Scott was invited back to contribute designs for later versions of the phone box, culminating in the design of the jubilee kiosk, which the GPO wanted to create for George V's silver jubilee in 1935. This design became known as the K6; eventually these were mass-produced and installed in every city, town and village in the country. It is this design that is the most familiar of all the telephone boxes created, and one that became an iconic symbol of Britain, along with the bulldog, bowler hat and Mini Cooper.

There is a K6 phone box inside the cathedral itself, located near the lifts for the central tower. It is very fitting that, inside Scott's biggest ever creation, you can see an example of one his smallest works – both truly magnificent in their own rights. You can learn more about his telephone boxes further on in this book when we encounter some rare examples of his K2s and K6s that are still in full working order near the town Hall. Sir Giles Gilbert Scott is buried outside the west entrance of the cathedral as, being Roman Catholic, he could not be buried inside. There is a commemorative plaque nearby to mark the spot.

Lord Derby's Tomb

One of the notable tombs to be found inside the cathedral is that of Frederick Arthur Stanley, the sixteenth Earl of Derby. Born in 1841, he went on to become a Member of Parliament for over twenty years before being appointed by Queen Victoria as Governor General of colonial Canada in 1888. During his five-year stay as Governor, he became fascinated by hockey and, persuaded by his children, who were avid players, donated a challenge cup to the game: The Stanley Cup. His main claim to fame, however, is his philanthropic work in the latter years of his life.

He does, however, have one other claim to fame. On 11 September 1888, whist opening the Toronto Industrial Exhibition in his official capacity of Governor General, he met inventor Thomas Edison, who was at the exhibition to demonstrate his new phonograph voice recorder. The recording made by Stanley that day is one of the oldest surviving recordings of the human voice still in existence.

Left: Telephone box in Liverpool Cathedral. Both cathedral and post box were designed by Giles Gilbert Scott.

Below: The Central Tower of Liverpool Cathedral, said by some to be the 'inspiration' for the design of the telephone box.

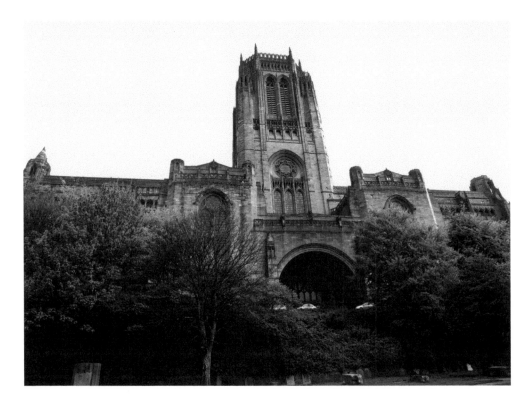

The Lucky Mouse on Lord Derby's tomb, Liverpool Cathedral.

The tomb of Lord Derby, Liverpool Cathedral.

On the tomb, hidden in the folds of the stone pillow below Lord Derby's head, you can find a small brass mouse, added to the monument by the tomb's architect. It is said that the architect found the cathedral to be so imposing that he reckoned no self-respecting church mouse would ever live there, so he incorporated a brass mouse into the design of the tomb. Local lore has it that if you rub his nose and make a wish, then it will one day come true. Consequently, his little mousy nose is now very shiny indeed.

Titanic Memorials

Hidden amongst the vast interior of the cathedral are a few small tributes to the RMS *Titanic*, the supposedly unsinkable ship that met its end on its maiden voyage, after colliding with an iceberg in the Atlantic Ocean on 15 April 1912. The *Titanic*'s connections to Liverpool are numerous; for one, the ship, which belonged to the White Star Line (a shipping company founded in Liverpool), was registered in the city; the captain, Edward Smith, lived here, and most of the crew were Liverpool born and bred. When the tragedy struck it was a bitter blow for the city.

Carving of *Titanic*, Liverpool Cathedral.

There are two windows with *Titanic* connections. One can be found behind the high altar and is dedicated to J. Bruce Ismay, chairman of the White Star Line. The other, found in the chapel of the Holy Spirit, is dedicated to Captain Edward Smith, who bravely went down with the ship on that fateful night. One of the little-known tributes to the ill-fated ship that resides inside the Cathedral can be found on a balcony just outside the Holy Spirit Chapel. If you look carefully, you can find a highly detailed sculpture of the *Titanic* sculpted into the balustrade.

CANNING STREET – RARE EDWARD VIII POST BOX ON THE CORNER OF BEDFORD STREET

According to Royal Mail, there are currently around 100,000 post boxes in use around the UK. Although they are such a common sight on our city streets that we tend to pass them by without a second glance, there are a few that deserve a closer look. Since their introduction in 1852, there have been over 150 different post box designs used in the British Isles, with subtle changes made over the years to their shapes, sizes and Royal ciphers (the stylised monogram of the monarch who was on the throne at the time of installation) inscribed on the doors.

The post box in Canning Street bears the cipher of Edward VIII, who was crowned in 1936, but whose reign lasted only 326 days. Edward abdicated from the throne due to the fact that his proposed marriage to Wallis Simpson, a previously divorced American heiress, was opposed by the British government on religious, political and legal grounds.

During his very short reign, only 161 post boxes bearing his cipher were installed. Out of those 161, only 145 are still in existence and just seventy-five of those still in use today, making this particular post box very rare indeed. You will also notice that since this is

Rare George VIII post box, Canning Street.

an earlier design than the more common Elizabeth II box, it is much thinner than its modern counterpart.

Finally, the next time you see a postal worker emptying a post box, spare them a small thought because the locks are all unique and each has its own key. Consequently, postal workers have to carry around large bunches of keys whenever they are on their rounds emptying the boxes.

RODNEY STREET - WILLIAM MACKENZIE'S TOMB

William MacKenzie was a civil engineer, born in Newbie, Dumfriesshire. He spent an extensive part of his career carrying out engineering work in Liverpool, including the digging of the railway tunnels near Lime Street and Edge Hill. In 1843, he made his home at 74 Grove Street, Liverpool, where he stayed until his death in 1851.

His unusual pyramid-shaped tomb, in the former St Andrews Church on Rodney Street, has attracted much attention and speculation over the years. One of the most persistent pieces of local folklore surrounding MacKenzie was that, as a keen gambler, he made a pact with the devil, offering his soul in exchange for good fortune on gambling tables. After making the pact, Mackenzie left instructions that, upon his death, his body should not be committed to the earth, but instead interred above ground in order to prevent the devil from claiming his soul. To this end he was entombed above ground in a pyramid, sat upright behind a card table with a winning hand of cards.

Unfortunately this is not true, nor are the stories of sightings of his ghost wandering around the area on cold, dark nights. So how did such a rumour get about? Like all urban myths, this

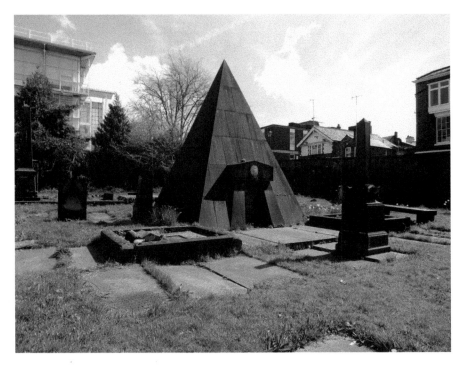

Mackenzie's Tomb, Rodney Street.

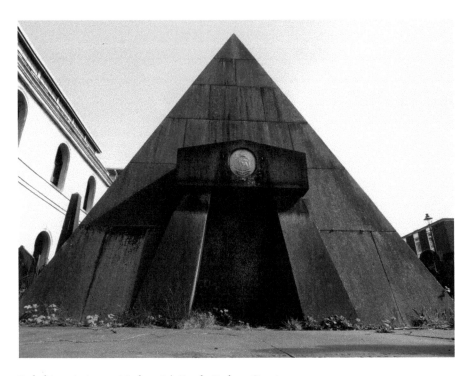

Faded inscription on Mackenzie's Tomb, Rodney Street.

story appears to have been borrowed from elsewhere and adapted especially for Liverpool. For instance, there is a similar tale from East Sussex, concerning another pyramid tomb belonging to a gentleman called John 'Mad Jack' Fuller. Legend has it that Fuller was entombed in his pyramid in full evening attire and top hat, seated around a table set with a lavish roast dinner and a bottle of wine. When his tomb was opened in 1982 for repairs, they discovered that this was untrue and that he had been buried in the conventional manner, with the tomb built over his grave.

There is a faded inscription on the door of Mackenzie's pyramid, which reads:

In the vault beneath lie the remains of William MacKenzie of Newbie Dumfrishire, Esquire who died 29 October 1851 aged 57 years. Also, Mary his wife, who died 19 December 1838 aged 48 years and Sarah, his second wife who died 9 December 1867 aged 60 years. This monument was erected by his Brother Edward as a token of love and affection A.D. 1868. The memory of the just is blessed.

This proves conclusively that Mackenzie was indeed buried underground, with the pyramid added by his brother seventeen years after his death. However, as local mystery writers and spooky tour guides will reluctantly tell you, the truth never gets in the way of a good story.

BOLD STREET

Bold Street is one of Liverpool's alternative gems. It started life as a ropewalk, a long thin strip of land used for rope manufacture. Rope was measured from the top of the strip to the bottom, which was deemed to be the standard length of rope required for the sailing ships of the day. Later on, as Liverpool's prosperity grew, houses were built on the surrounding land for merchants who traded on the docks. Bold Street was named after Jonas Bold, a slave merchant, sugar trader and banker, who later became Lord Mayor of the city. Eventually the houses gave way to businesses and the area became known as the 'Bond Street of the north'.

Today's Bold Street is very different from that of its humble origins. Nowadays, the street is famous for its cafés, bars and independent shops, which sell everything from original art to alternative fashion. The street has an unmistakable cosmopolitan feel about it and is a very refreshing change from many of the other streets found in the heart of the city. We start our tour of this interesting street from the top end near St Luke's, the bombed out church.

THE SHELL SHIP

130 Bold Street

Tucked away at the very top of Bold Street stands an old dilapidated shop, which has lain unoccupied for at least thirty years. The only clue to its past role is a dirt-streaked, lurid yellow and red perspex sign that hangs above the shop entrance, emblazoned with the single word 'Antiques'.

Above left: The enigmatic Shell Ship, 130 Bold Street.

Above right: 130 Bold Street, birthplace of Sebastian Ferranti, the man whose pioneering work in electrical distribution made the National Grid a reality.

Most of the people who wander up and down this busy thoroughfare seem to be completely oblivious to the shop's existence, passing by without even a cursory glance. Yet, if you take the time to stop and peer through its barred and grime blackened panes, you will see the most curious window item on display in Liverpool.

Cradled on fish-shaped metal supports, sits a 2-metres-long (6-feet) hand-made model of a cabin cruiser. The boat, which bears the name *Avril*, is completely covered from prow to stern in seashells and takes up sole occupancy in the old antique shop's window. The boat has been there for as long as anyone can remember, sitting timelessly as the world around it changes at a dizzying pace.

At first glance, the shell ship (as it is known locally) looks like a hideous throwback to the sort of thing you would expect to see on display in an early 1960s seaside resort. However, if you look more closely, a strange beauty emerges in the way that the shells have been skilfully arranged in an intricate and complex mosaic. Bi-valves, molluscs, winkles, conch and a dozen other variety of shell adorn every surface of the boat, interjected by the occasional fish ornament or Union Jack. There is even a pair of old, possibly 1930s, Mickey Mouse figurines hidden amongst the shells on the deck, adding to the air of antiquity exhibited by the model. The cabin, furnished with miniature tables and chairs, shows the amount of care and attention to detail that the builder lavished on this project. It is a true labour of love, which must have taken the model maker a considerable amount of time to complete.

As well as being the home of the enigmatic Shell Ship, 130 Bold Street has another secret to reveal; it was also the birthplace of a man who would go on to transform our way of life forever, heralding in a new age – the electrical revolution. His name was Sebastian Ferranti.

Born in 1864, in a dingy upstairs room above his parents' photographic arts studio, Sebastian Ferranti became an innovator and pioneer in the field of electrical engineering. His groundbreaking work in A/C electricity and electrical transformers made electrical power distribution a practical reality, which paved the way for the creation of the National Grid. Modern power stations still use methods and systems invented by Ferranti.

In a roundabout way, it is apt to think that the Shell Ship, which was almost certainly created with the aid of power tools such as electrical drills, jigsaws and a hot glue gun, now resides at the birthplace of the man who made electrical distribution, and therefore electrical tools, a reality. But who was the builder? Who was it built for? Why did it end up in the shop window? More importantly, why has it remained on display, untouched for around three decades? Maybe one day these questions will have answers, but until then, the Shell Ship remains: an enigmatic and timeless sentinel on the threshold of the equally enigmatic Bold Street, a place where, if you believe the stories, time has a tendency to play tricks on unsuspecting passersby.

BOLD STREET TIMESLIPS

For many years there has been a persistent belief, or piece of folklore, that the area immediately around Bold Street is a 'time portal' or 'window' into the past. Since the 1970s, there have been over 100 reports from seemingly reliable, sane people, who all claim that they have somehow travelled back in time whilst walking down Bold Street or the surrounding streets.

Alleged location of a timeslip back to the 1950s, Bold Street.

The most famous story is that of a police officer called Frank who, in 1996, was walking up the ramp from Liverpool Central station, heading towards Dillon's (now Waterstones) bookstore to meet up with his wife. As Frank emerged into Bold Street, he immediately sensed that something was not quite right. The first thing he noticed was that the road was cobbled, not tarmacked. The street was filled with people who appeared to be dressed in 1940s or 1950s clothing. He was so absorbed by the scene that he was nearly run over by a 1950s-style box van that had the word 'Caplins' stencilled on the side. Slightly rattled, Frank crossed the road and headed towards where Dillons should have been. However, instead of finding a bookstore, Frank found a haberdashery store called Cripps. He was completely perplexed. As he entered the shop he was passed by a confused-looking girl wearing modern clothing, and carrying a Miss Selfridges bag. Frank caught her arm and asked her if she was seeing what he was. She replied, 'I thought this was a new clothes shop but when I went in it was full of books.' Frank let her go and suddenly, the interior of the store shimmered briefly; Frank found himself standing in the foyer of Dillons.

Perplexed by the whole episode, Frank contacted local mystery writer Tom Slemen, who did some checking on Frank's behalf. Tom's research discovered that a local business called Caplin's did once exist, and that the shop where Dillons resided was once a haberdashery store called Cripps. It appears that Frank had somehow managed to travel back to the Bold Street of the 1950s.

This story alone can easily be dismissed, but it just one of many reported incidences of people claiming to have travelled back in time whilst in the vicinity of Bold Street. ParaScience, a highly respected paranormal investigation team, have investigated over seventy reports of time slip incidents in the area, most of which appear to involve people momentarily slipping back to the 1940s or 1950s. Can all the reports be dismissed as cases of over-active imaginations, or hoaxes, or is there something very interesting going on in the Bold Street area?

There is one final tale in the Bold Street time slip saga that I would like to share with you; it happened to me. Back in 2008, I was walking up Bold Street with a friend, when he spotted what he thought was a one pence piece on the pavement. Because my friend is keenly superstitious, he picked it up for luck. To his bewilderment he discovered that it wasn't a penny, but a half pence piece that had been minted in 1975. This puzzled the pair of us, as we were both aware that the half pence piece had been demonetarised and taken out of circulation in December 1984. It was the first time that either of us had set our eyes on one in decades. Could this humble coin be physical proof that something very odd is happening on Bold Street? Or could it merely be an old forgotten coin that has fallen out of someone's coat or wallet as they passed by? It is probably the latter, but, with all the stories of time slips from the area, it makes you wonder.

JEFF'S WELL

72 Bold Street
Further down Bold Street is a clothes shop called Soho that has a circular brick construction built in the middle of the shop floor, topped with a curved ironwork cage. It is often surrounded by clothes racks and therefore not readily apparent to the casual onlooker. If you peel away the racks and look down over the wall, you will be greeted with the sight of a 60-foot-deep well, dating back to the seventeenth century.

The well was discovered by the shop owner Jeff Pierce, while renovating the cellar. Jeff had an eight-man team working on removing an old air-raid shelter, when he discovered a small hole in the floor. At first he assumed it to be a rat hole. Over the next few days he attempted to fill it in, but it kept on re-opening. After a few attempts he decided to investigate and widened the hole enough to shine a torch down it. To his amazement, he discovered a pit approximately 30 to 40 feet deep, filled with water. Convinced that he had found something significant, Jeff contacted Liverpool Museum, who sent a team out to investigate. After a few days of research and digging, the archaeologists informed Jeff that he had unearthed an ancient water well that dated back to at least the seventeenth century. Back then most of the area surrounding the well would have been fields. It would be at least a hundred years before the first houses arrived.

Liverpool Museum declared the well to be 'one of the greatest finds in Liverpool City Centre.' Archaeologists stayed there for three weeks unearthing all manner of finds, including clay pipes and pieces of porcelain. They also discovered several little channels cut into the ground leading into the well. These channels were almost certainly used by the rope makers to lower their ropes into the water, so they could plait them together while drawing them out of the well.

Above left: Jeff's Well, inside the shop at 72 Bold Street.

Above right: Looking down Jeff's Well, 72 Bold Street.

Jeff decided to build the well up a further 20 feet from the basement to the shop floor, in order to make a feature of it in the store. Once completed, he opened it up as a wishing well, donating all money dropped into it to the Alder Hey Rocking Horse Children's Charity. Jeff has moved on now, but the well is still there and still attracting the attention of the odd curious shopper.

ART DECO BUILDINGS

Leaf Tea Rooms, 65-67 Bold Street / Oxfam, 35-37 Bold Street

As you head down Bold Street, take a few moments to look up. Above the shop signs you will see some amazing Georgian, Victorian and Art Deco-style buildings. One of the most outstanding examples of an Art Deco building front can be found at 65-67 Bold Street, which is currently home to the Leaf Tea Rooms. Originally built in 1826 as a chapel, the building was later substantially rebuilt in 1850, as an entertainment hall called the Queen's Hall. Over the next sixty years it went through a number of name changes, starting with the Panorama Hall, then the Queen's Operetta House and finally the Bijou Opera House. By 1890, the building became the Yamen Café.

In 1935, the building was acquired by William Watson (a motorcar dealer), who built the magnificent Art Deco front and used the premises as a car showroom. Note the repeating W motif throughout the design that covers the front of the building.

Another building of note is 35-37 Bold Street, which is currently home to Oxfam. This building was constructed in 1939, again for William Watson as a car showroom. Inside the

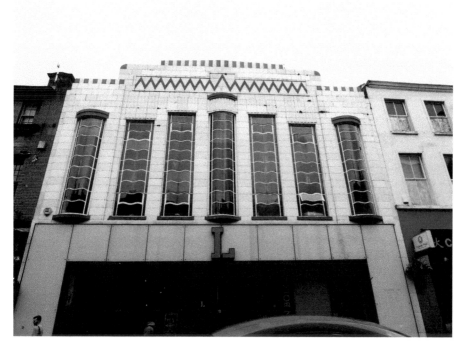

Art Deco shop front, 65–67 Bold Street.

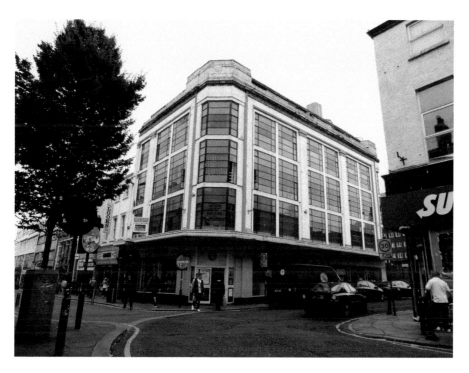

Art Deco shop front 35–37 Bold Street.

store is a lift large enough for transporting cars to/from the upper floors. The building is an outstanding example of Art Deco design.

These magnificent buildings are invisible to the casual observer, due to the tendency of our eyes to never stray above the artificial line drawn at street level by modern shop signs. It is a pity that what lies above the shops is not noticed often; most of the building fronts above street level have hardly changed in over 100 years. However, once you first look up, you will be absolutely fascinated by what you can see.

A RARE BANKSY

At the back of Argos in Wood Street

In the loading bay entrance to the rear of the Argos store at 18-20 Bold Street, there is an extremely rare piece of graffiti, created by the enigmatic street artist Banksy. It depicts a rat with a ghetto blaster, and is stencilled just inside the rear access way to the shop. It was put there during the 2004 Biennial, a Liverpool arts festival that is, as the name states, held in the city every two years.

Although Banksy was invited to contribute some work to the biennial, the officials got far more than they bargained for. Soon the Ropewalks quarter of the city was literally infested with graffiti rats stencilled on walls, shutters and billboards. The most noticeable of Banksy's

Banksy's *Ghetto Rat* at the back of Argos, Wood Street.

ratty creations was the *Big Rat*, a 6-metres-tall (twenty-foot) painting of a rodent holding a spray can, which dominated the front of the derelict Whitehouse pub on the corner of Duke/Berry Street.

Due to major renovation work that took place all over the Ropewalks quarter for the Capital of Culture celebrations in 2008, almost all of Banksy's creations have now disappeared. They have either been painted over or removed by cleaning jets. The *Ghetto Rat* just inside the rear entranceway of Argos has only survived because it is situated behind a pull down shutter that is locked when the store is closed. It is such a pity that almost all traces of Banksy's art have been removed or destroyed; his work is now highly regarded and fetches huge sums of money in the art market. Destroying a Banksy art piece is now considered the modern equivalent of painting over an original Picasso or Van Gogh. Only in Liverpool, it seems, could such a crowd-pulling piece of art be unceremoniously erased without a second thought.

The *Big Rat* on the Whitehouse was believed to have been destroyed when new owners renovated the pub. However, in April 2014, it was announced that the artwork was carefully removed by a team of renovation experts and taken to London to be auctioned for charity. It is unclear exactly how much the piece fetched, but its estimated value was somewhere in the region of £1 million.

Banksy's *Ghetto Rat* appears to be the sole survivor of his 2004 art terrorism spree around the Ropewalks quarter, but it is not the only piece of Banksy art in the city. In 2010, Banksy created another large piece on the wall of a car park near Water Street, which will be discussed later in the book.

How to View the Ghetto Rat
If you wish to see the Argos Ghetto Rat, you will have to walk down Wood Street during Argos' opening hours; otherwise the Rat will be safely tucked away behind the bay's steel shutters.

GRAND CENTRAL HALL

35 Renshaw Street L1 2SF
The Grand Central Hall is a Grade II listed Art Deco-style building, purpose built as a Wesleyan Mission church. Opened in 1905, this building was designed in an Art Deco-style, in order to appear more attractive to the public than a traditional church. This was in the hope that they could draw people into the building, away from the sins of drinking and gambling. To this end, the church set up shops, tea rooms, reading rooms and assembly rooms on the premises. Patrons who took advantage of the facilities were encouraged to attend services and religious discussions.

In December 1908, a cinema was introduced to the hall's first floor. Calling itself The New Century Picture Hall, its aim was to encourage down-and-outs to watch films that reinforced the Wesleyan philosophies of clean living and temperance. These shows proved to be very popular, and the hall was often packed to capacity, despite having ample seating for around 3,500 patrons. It became the second largest cinema in Liverpool, second only to the Sun Hall in Kensington. Price for admission was a modest 3 or 5*d*. The cinema ran until 1945.

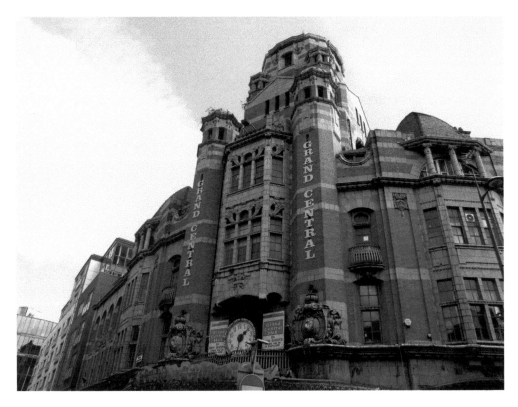

The outside of the Grand Central Hall, Renshaw Street.

When fire destroyed the Old Philharmonic Hall in 1933, Grand Central became the temporary home of the Philharmonic Orchestra up until 1939, when the new Philharmonic Hall was constructed.

After the Second World War, the hall went into decline and eventually fell into disrepair. Unable to afford the hefty cost of its upkeep, the Methodists sold the hall in 1990. It remained largely unused until around 1997, when a major refit was undertaken and it was converted into the Barcelona Bar and Nightclub. Eventually this also folded, and the building was reopened in 2006, as a market place for alternative and independent shops, which currently occupy the ground and basement floors of the building.

These floors are still decked out with the former night club's decor, consisting of ornate metalwork formed into organic flowing shapes that represent an undersea kingdom. This is complemented by rippling plasterwork covering the ceiling, painted in pastel blue and white to further echo the underwater theme. The shops weave around the interior like an ancient labyrinth, drawing you into an alternative magical mystery tour shopping experience.

Upstairs on the first floor, the old Roscoe Hall (former home of the cinema), has now been renamed The Dome. It is an all-purpose performance space used for all manner of entertainments, ranging from theatre, award ceremonies and live music to comedy performances and even indoor wrestling. The interior of the hall has changed very little since being relinquished by the Methodists, save for the addition of a bar area and the levelling of the floor space.

Overhead the magnificent Dome is an excellent example of Art Deco design at its finest. The upper circle is also breathtaking, and gives you an impression of what it would feel like to step back in time to the turn of the nineteenth century.

Hidden behind the newly installed cinema screen, above the stage, can be found one of the hall's secret treasures – the third largest pipe organ in Liverpool. This was built in 1904 by William & Beard, and is still in full working condition. When uncovered, it is a truly magnificent sight that dominates the stage wall. If you spend a little time in the hall wandering around its floors, you will come to agree that it is one of Liverpool's fabulous hidden gems.

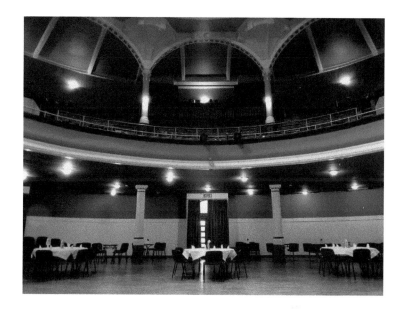

Interior of the Roscoe Hall AKA 'The Dome', upstairs at the Grand Central Hall.

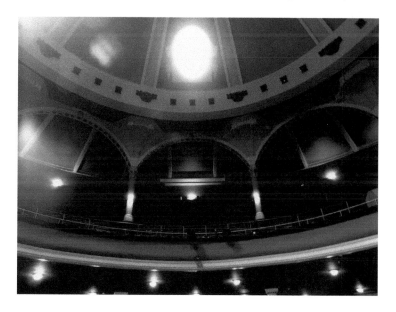

The beautiful upper circle in The Dome.

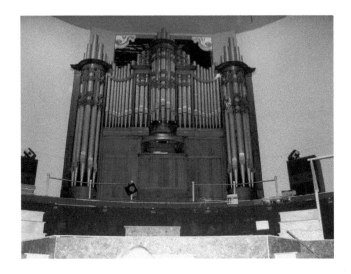

Impressive organ in the Roscoe
Hall AKA The Dome, upstairs at
the Grand Central Hall.

MATHEW STREET

Originally called Mathew Pluckington Street, named after a Liverpool merchant, Mathew Street
is undoubtedly one of the most famous streets in the world. This is principally because of its
association with the Cavern Club and the Beatles. However, it is also the location of several other
venues that have spawned generations of poets, artists, actors, writers and musicians, who later
shot to world stardom. Put simply, Mathew Street is the physical and creative centre of the city.

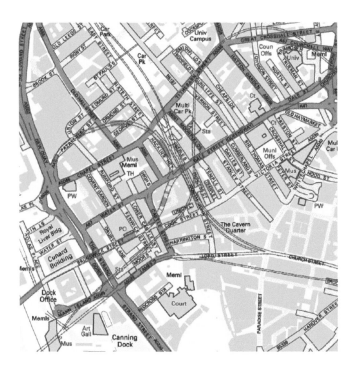

THE CAVERN CLUB – AND THE CAVERN BELOW THE CAVERN

10 Mathew Street

The Cavern Club, legendary 'birthplace' of the Beatles, is quite possibly the most famous club in the world. Located in a cellar below an old fruit warehouse, the club started out as a Jazz club, opening its doors on 16 Jan 1957. Over the years, the club has hosted a wide range of artists from all manner of musical genres, such as rock and roll, skiffle and Merseybeat (the latter created and honed by several Liverpudlian bands, in particular the Beatles, who were instrumental in putting the Cavern on the map).

The Cavern continued to showcase artists from all over the world until its closure in May 1973, to make way for a new ventilation shaft needed for the underground rail loop line that ran below the street. The bulldozers moved in in mid-June 1973, demolishing the old fruit warehouse above and temporarily filling the Cavern with rubble. This was regarded by many as a 'wanton act of civic vandalism perpetrated by a council who did not understand the historical importance of the club to Liverpool.'

Eventually, British Rail announced that they had changed their plans and decided to relocate their ventilation shaft elsewhere. In the meantime, locals used the levelled Cavern as an informal car park, until the untimely and shocking death of John Lennon galvanized officials into action, to see if the Cavern could be re-opened.

The site was dug out and inspected in 1982, where all hope of resurrecting the Cavern was dashed; it was discovered that the foundations were incredibly unsafe. At the same time, builders found an old shaft in the floor that led to a huge hole filled with water. In essence,

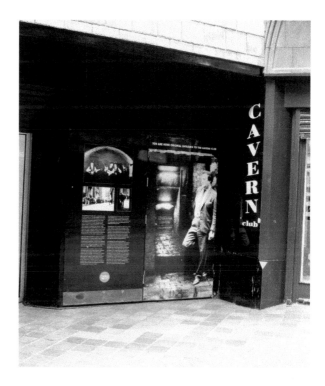

The location of the entrance of the original Cavern Club, 10 Mathew Street.

they had discovered a cavern beneath the Cavern. The architect and site agent explored the hole using a rubber dinghy. The water-filled hole was found to be very large, measuring 36.5 metres (120 feet) long, twenty-one metres (seventy feet) wide and around 2.4 metres (8 feet) deep. They found marks on the walls, indicating that it was man made. Initially they were totally perplexed, but later it was discovered that the hole was in fact a reservoir, constructed in 1850 and later abandoned.

When all hope of rebuilding the Cavern in its original location had gone, thoughts turned to the creation of a shopping complex on the land. The water was pumped out, the hole filled with concrete and work started on creating what is now the Cavern Walks shopping complex.

Meanwhile, next door to the former site of the Old Cavern, work commenced on the construction of a new Cavern Club, using bricks reclaimed from the original club. The new Cavern was constructed using the same dimensions and occupies around seventy-five per cent of the original Cavern's site. However, due to the foundation problems, the new Cavern was constructed much deeper underground than the original. The new Cavern opened its doors in 1984.

There has been a persistent rumour that, since the new Cavern occupies seventy-five per cent of the same space as the original, one of the store rooms in the new Cavern used to belong to the old Cavern. This is simply not true due to the increased depth of the new establishment. However, the fire exit in the new Cavern does come out at the exact spot where the original Cavern's entrance used to stand, so in a small way it can be considered to be the last feature of the original Cavern still in existence, in spatial terms at least.

ERIC'S

9 Mathew Street
Directly opposite the site of the original Cavern Club stands Mathew Street's other highly influential music venue, the legendary Eric's. Established by Roger Eagle, Ken Testi and Pete Fulwell as a venue for alternative and non-mainstream artists to perform, Eric's opened its doors on 1 October 1976. Soon, Eric's became the epicentre of the local music and cultural scene. Like the Cavern before it, Eric's became a breeding ground for a new generation of Liverpool musicians and bands. Groups such as Echo and the Bunnymen, Orchestral Manoeuvres in the Dark (OMD), Dead or Alive, The Teardrop Explodes, The Lightning Seeds, It's Immaterial, The Christians, Frankie Goes to Hollywood, and the KLF, amongst many others, all owe their very existence and subsequent success to Eric's in some way.

The list of groups that played Eric's reads like a who's who of the punk/post punk music generation, with acts such as Elvis Costello, Buzzcocks, The Clash, Joy Division, Ramones, Siouxsie and the Banshees, Blondie, The Jam, The Slits, The Stranglers, Ultravox, Wire, XTC, X-Ray Spex having performed to capacity crowds. Several bands, such as The Police, Sex Pistols, and U2 actually played their early gigs there before finding international success. It was a very special time for Liverpool, which once again became the world's musical capital.

Eric's closed its doors a mere four years after first opening, but in that short space of time it had achieved so much, helping to shape and nurture the music and culture of a generation. In a small way, its legacy lives on; the musicians whose careers started in the club have gone on to manage and produce new generations of musicians, who are now taking the world by storm.

Eric's was bought by developers, who eventually turned the venue into a trendy nightclub, and the astounding story of Eric's passed into local folklore.

For a short time in 2011, Eric's was re-opened, but the move proved unpopular (mainly because the people involved had no association whatsoever with the club's founders, and were attempting to capitalise on the brand). It closed a short while later, and now lies dormant, a shadow of its former self. But its place in the history books is assured and its legend lives on.

JUNG, LEY LINES AND THE 'LIVERPOOL SCHOOL OF LANGUAGE, MUSIC, DREAM AND PUN'.

Flannagan's Apple, 18 Mathew Street

Further down Mathew Street is No. 18, a tall ex-warehouse that is currently an Irish pub called Flannagan's Apple. Long before it was a pub, it was a location that was undoubtedly the creative heart of the city. The story of this amazing building begins with poet and artist Peter O'Halligan, one of Liverpool's more eccentric characters, who had become obsessed with the writings of the Swiss psychiatrist and psychotherapist Carl Gustav Jung. Jung had more than a passing interest in mysticism, religion, spirituality and the occult, which led him to develop theories on personality archetypes, dream analysis, collective consciousness and synchronicity.

In his book *Memories, Dreams, Reflections*, Jung described a dream he had experienced, in which he found himself walking around Liverpool's dark and sooty streets in the rain. Presently, he came across a square where many paths converged. In this square was a pool of water with an island at its centre. On the island was a magnolia tree, illuminated by a

The former Liverpool School of Language,
Music, Dream and Pun, 18 Mathew Street.

beam of golden light. In the dream, Jung's companions could not see this wonderful tree, and remarked about how abominable the weather was. Taken in by the beauty that only he could see, Jung then came to the realisation that 'Liverpool is the Pool of Life'.

O'Halligan became obsessed with Jung's dream and tried to track down the location that Jung had described. After much searching, O'Halligan found a place that not only matched the description, but was also a spot where he believed that several ancient ley lines converged. He immediately purchased the warehouse nearest to it and, in 1974, set up the Liverpool School of Language, Music, Dream and Pun.

The building housed a market called Aunt Twacky's that sold all manner of weird and wonderful clothes, crafts and hippy paraphernalia, which could not be bought anywhere else at the time.

Later, a café opened on the second floor. Called the Armadillo Tea Rooms, it was the place where many of the future movers and shakers of Liverpool's second creative revolution first met, formed lasting friendships, and mapped out their dreams and ambitions. The café also doubled as an art gallery and rehearsal and performance space for bands, where up-and-coming Liverpool bands, such as The Yachts and Deaf School could often be found rehearsing in the corner. The building was a bohemian haven, with no real purpose or agenda other than to be a place where creativity could be nurtured and dreams turned into reality.

Peter O'Halligan eventually persuaded renowned showman and madman Ken Campbell to come along and set up his Science Fiction Theatre of Liverpool, where the stage was set for even more eccentric shenanigans. The first play that the Science Fiction Theatre performed was an adaption of the *Illuminatus* book trilogy by Robert Shea and Robert Anton Wilson. Campbell chose this work without reading it, purely on the basis that it had a yellow submarine on its cover, which he took to be an omen because of Mathew Street's connection with the Beatles.

The production featured actors such as Bill Nighy, Jim Broadbent and David Rappaport, who at the time were unknown actors. Not to be outdone, the backstage crew and theatre band, comprising Bill Drummond, Jane Casey, Ian Brodie, Pete Burns, Ian McCulloch, Holly Johnson and Paul Rutherford, all went on to change the face of music by forming the highly influential group Big in Japan. Described as a 'super-group in reverse', this collective spawned bands such as The KLF, Pink Military, The Lightning Seeds, Dead or Alive, Echo and the Bunnymen, Frankie Goes to Hollywood, and the hugely successful Dance Nightclub Cream - all because of meeting up at the Science Fiction Theatre of Liverpool.

In 1976, Peter O'Halligan decided to stage the first of his Jung Festivals in Mathew Street. It was a carnival of the absurd, where people jumped off high ledges into skips filled with custard, women dressed as Carmen Miranda and people displayed ice sculptures from the back of refrigerated trucks, all against a backdrop of live music performed outdoors in the street. A weird but fun time was had by all. At this first festival, a specially made bust of Jung was unveiled on the side of the building, with the statue resting on a special piece of stone specially brought over from Jung's home in Switzerland. The statue suffered considerable damage over the years and so another was made, and installed at the front of the building where it still rests today.

The spot that marks the 'ley line' conjunction, 'discovered' by Peter O'Halligan, is marked by a rectangular manhole cover just across the way from the entrance of Flanagan's Pub.

Above: Eric's, Mathew Street.

Right: Bust of Carl Jung on the front wall of Flannagan's Apple, 18 Mathew Street.

'Grid marks the spot': the alleged point in Mathew Street where several ley lines converge, opposite Flannagan's Apple, 18 Mathew Street.

One piece of popular local folklore tells of Bill Drummond's apparent obsession with the ley line conjunction on Mathew Street. It is said that he believed there was a cosmic line of energy that came down from space, bounced off Iceland and then travelled down Mathew Street, before disappearing down the grid and carrying on through to Papua New Guinea, and heading back out into space. In 1983, Bill Drummond (in his role as manager of Echo & the Bunnymen) arranged for the Bunnymen to perform a special concert in Reykjavik, while he stood on the grid in Mathew Street to see what happened. Apparently nothing did. It is unsure if this actually happened, or if it was merely a tall tale made up on the spot by Drummond during a dull interview. But knowing Drummond, the man who controversially burnt £1 million of his own money in a remote cottage in Scotland, and erased the whole of his band's (The KLF) back catalogue, anything is possible. Whatever the truth really is, the grid still occasionally attracts the attention of fans and mystics.

There is one final part of the saga of the Liverpool School of Language, Music, Dream and Pun that needs to be emphasised. In Jung's dream of Liverpool, he described a square where several pathways converged near a pool of water: the Pool of Life. Despite the complete lack of any pool in Mathew Street, Peter O'Halligan was adamant that the warehouse he bought marked the spot that Jung had dreamed about. Unbeknown to Jung, O'Halligan or anyone else at the time, a pool did once exist in Mathew Street, in the form of the underground reservoir, rediscovered in 1982 under the Cavern. Was this a spooky premonition, a mere coincidence or an example of Jungian synchronicity at play? Who can say?

GORILLA WITH LIPSTICK

Cavern Walks Car Park, Harrington Street

Our final spot of interest in the Mathew Street area lies to the rear of the Cavern Walks shopping complex in Harrington Street. On the arch above the Cavern Walks car park, you will find a small sculpture of a gorilla holding a compact and lipstick.

Around the time that the Cavern Walks was being constructed, noted architect Norman Foster announced that 'Art is to architecture as lipstick is to a Gorilla', meaning that putting art on a building was completely pointless. Cavern Walks architect David Backhouse saw the quote and thought it would be a bit of fun if he could create a cheeky 'homage' to Norman's words, commissioning a local sculptor to create the piece. Once it was put in place, Backhouse made a picture postcard of it and sent it to Foster, but alas never got a reply. Liverpool-born David Backhouse is living proof that Liverpool's keen sense of humour is still very much alive and kicking.

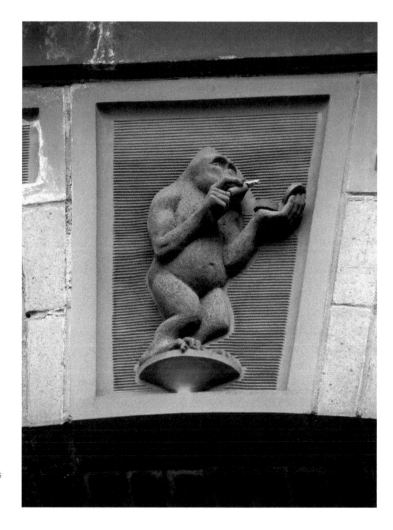

Gorilla with Lipstick
above the Cavern Walks
Car Park entrance,
Harrington Street.

4. A Walk Around the Business Quarter

INTRODUCTION

The Business Quarter stands upon the original seven streets that were established when Liverpool was granted its charter in 1207. They contain an assortment of locations and artefacts that each reveal an aspect of Liverpool's long and rich history.

In this section we will visit some magnificent monuments, see the only surface-based relic of Liverpool's medieval past, and finally visit the place where the story of Liverpool really started, the site of the world's first commercial enclosed wet dock, and much more besides.

DIGGING AROUND DERBY SQUARE

Derby Square is a large open paved space in the heart of the Business Quarter of Liverpool. The central focus of this area is the Victoria Monument, a towering edifice of bronze and stone, built in 1906 as a memorial to Queen Victoria. The monument stands upon the former sites of Liverpool Castle and St George's church. Liverpool Castle was built around 1232–37 on what was then headland. At the time, the shore of the Mersey was located much further inland than

Queen Victoria's Monument, Derby Square.

it is now, with the water's edge located at the bottom of James Street. Liverpool Castle was an immense structure built out of huge slabs of sandstone and ringed by a moat that was cut out of the solid bedrock. The castle remained in place for over 500 years, in which time it succumbed to the ravages of the English Civil War and eventually fell into disrepair. Around the early 1700s, the castle was demolished and the moat filled in to create a market square. A few years later, St George's church was erected and took pride of place in the area, until eventually it also fell into disuse and disrepair. St George's was demolished in 1899.

Although there are no visible remains of either the castle or the church above ground, there is plenty of evidence of their existence below the square. During excavations to lay pipe work and construct public toilets, workers came across both the foundations of the church and remains of the old castle moat, both perfectly preserved.

Queen Victoria's monument is a magnificent Neo-baroque structure designed by Liverpool architect F. M. Simpson. The four groups of figures around the monument's pedestal represent agriculture, commerce, industry and education. On top of the columns that support the central dome are four allegorical bronze figures representing Queen Victoria's personal virtues: justice, wisdom, charity and peace, with a final bronze figure at the very top of the dome representing fame.

The monument is mostly constructed out of limestone and Portland stone, which, in places, contains fossils. In particular, if you look at the limestone steps at the bottom of the monument on the side facing the courthouse, you can find large fossilised Brachiopod shells. Higher up the statue, in the Portland stone, can be found the fossil imprints of conical

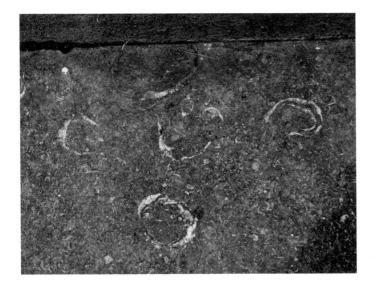

Jurassic Bivalve fossils
on Queen Victoria's
Monument, Derby Square.

Portland Screw fossil
imprints on Queen
Victoria's Monument,
Derby Square.

seashells, known to the quarrymen as 'Portland screws'. These date back to the upper Jurassic Period (152–145 million years ago).

The most remarkable thing about the Victoria monument, however, is that it survived completely unscathed by the heavy bombing inflicted upon the area in the May Blitz of 1941, which virtually flattened the whole area. Its survival is nothing short of a miracle.

There is another unfortunate feature on the monument that always raises a smile for people in the know. If you stand across the road on the pavement at the start of Castle Street and look towards the monument, the scroll that Victoria is holding in her hand resembles a flaccid penis poking out of the Queen's robes. Viccy's willy, as it is known locally, is one of Liverpool's cheekiest (and best kept) secrets.

Viccy's Willy on Queen Victoria's Monument, Derby Square.

CASTLE STREET - THE SANCTUARY STONE

Opposite NatWest Bank Castle Street

Along Castle Street, just opposite NatWest, sits a small round stone embedded in the pavement. Measuring approximately 46 cm (18 inches) in diameter, with four deep parallel score marks running across its face, this unremarkable-looking stone is the only surviving surface based relic from the city's medieval past. Its purpose was to act as a boundary marker for the city's medieval fairs. During the fairs, the normal rules of law and order were suspended within the boundary markers, meaning that debtors and thieves were free from arrest as long as they did not stray beyond that boundary. The Sanctuary Stone was originally one of four such markers, but over time the others have long since disappeared.

The stone has been moved several times in its history, and subsequently has several coins buried underneath it. When the stone was relocated from the middle of the road to the pavement in 2011, workers discovered pennies from 1937 and 1947 hiding below it. When it was relocated, a modern £1 coin was added to the collection.

DALE STREET – SIGNS OF WAR
ROYAL BANK OF SCOTLAND – 1 DALE STREET

During the May Blitz of 1941, many of the buildings in the Business Quarter were either destroyed or badly damaged by exploding bombs or heavy-calibre bullets fired from enemy aircrafts, as they swooped low over the city. If you take a look at some of the buildings that

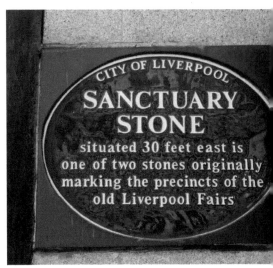

Above left: The Sanctuary Stone, Castle Street.

Above right: New plaque for the Sanctuary Stone, Castle Street.

Above left: Strafing damage from the Second World War on the Royal Bank of Scotland Building, Dale Street.

Above right: Strafing damage caused by aircraft guns on the Royal Bank of Scotland Building, Dale Street.

surround the Town Hall you can see the odd pockmark here and there, caused by enemy fire. However, on the Royal Bank of Scotland building right next door, you can see lines of strafing running diagonally down the full length of the building from top to bottom. It is a lasting reminder of the intensity of the German raids that took place in the city during the war.

Germany regarded Liverpool as a prime target because of its extensive dock system. During the battle of the Atlantic, convoys entered or left the docks on a daily basis, carrying food, fuel, weapons and troops that were vital to the war effort. In one of the most savage bombing campaigns ever undertaken against the UK, Germany attempted to wipe Liverpool off the map. Between the 1 and 8 May 1941, German planes dropped a staggering 870 tonnes of high-explosive bombs and over 112,000 incendiaries on the city, killing around 3,800 people and leaving many more badly injured. The area around Canada Dock holds the unfortunate record of being the most bombed square mile during the war.

In an ironic twist of fate, during the last air raid on Liverpool on 10 January 1942, the Luftwaffe destroyed several houses on Upper Stanhope Street. One of these was No. 102, the home of Adolf Hitler's half-brother, Alois.

NELSON MONUMENT

Exchange Flags

At the back of the Town Hall is a semi-enclosed plaza known as Exchange Flags. Originally, this was a central trading place for merchants, but eventually the space proved to be too small for the increasing number of traders in the city, and business moved to the Cotton Exchange on Old Hall Street around 1808.

The new square underwent a transformation with the construction of new office buildings, and the whole plaza was paved with large flagstones.

At the centre of this large flagged area is a magnificent monument, which celebrates the life and achievements of Horatio Nelson, Britain's most celebrated navy commander.

Nelson held a special place in the hearts of the people of Liverpool because of his masterful control of the sea lanes around Britain, protecting the waters from marauders and ensuring the sea lanes remained open for traders to safely ply their trade.

He was awarded the freedom of the borough and a special ceremonial sword was commissioned in his honour. Unfortunately, before he could attend the hand over ceremony, he was killed in action during the Battle of Trafalgar. The sword now has pride of place in a display cabinet in the Town Hall. Upon Nelson's death, it was decided that a monument in his honour should be placed in a prominent position in the city. The money to construct the monument was raised exclusively by public subscription, making it the first ever monument in Liverpool to be paid for in this way.

Originally it was unveiled in 1813, but was later moved to Exchange Flags in 1866, where it has remained ever since. The monument was designed by Mathew Cotes Wyatt and sculpted by Richard Westmacott. It features four prisoners in chains below the main sculpture, which represent Nelson's four greatest sea victories: Cape St Vincent, The Nile, Copenhagen and Trafalgar.

It is an impressive work of art that has been hailed as a masterpiece, hence its Grade II listed status with English Heritage. It is not just a monument, however, for it also doubles

Above left: Nelson's Monument, Exchange Flags.

Above right: Death draws near to Nelson, Nelson's Monument, Exchange Flags.

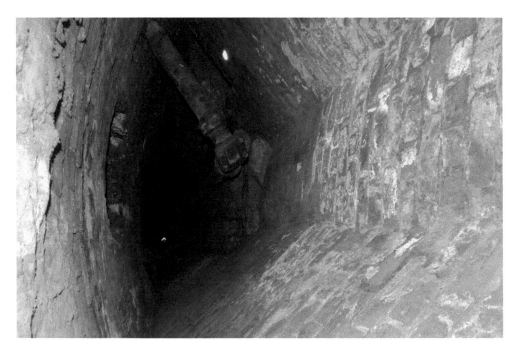

Looking down the hidden ventilation shaft below Nelson's Monument, Exchange Flags.

as a ventilation shaft for an underground car park beneath the plaza. If you look down one of the strategically placed grills around the monument's base, you can see the foundation brickwork disappearing into the darkness.

Formerly an underground warehouse space, the car park is used exclusively by the surrounding offices and luxury accommodation as a convenient secure parking space in the heart of the city. So if you ever find yourself standing on Exchange Flags in the dead of night and can hear the revving of car engines seemingly coming from out of nowhere, now you know why.

Rare Phone Boxes

Around the side of the Town Hall, opposite the old Martin's Bank building, stand two classic red telephone boxes. At first glance the pair looks identical, but in actual fact they are two completely different designs.

In 1924, Sir Giles Gilbert Scott (the architect who designed the Anglican Cathedral) provided the winning design in a competition to create a new phone box for the General Post Office. His design, christened Kiosk No. 2 (or K2) for short, was soon put into production. The first two K2s were installed in London in 1926. Scott wanted the boxes to be coloured silver, with a duck egg blue interior, but the Post Office decided to paint them red to make them highly visible.

Above left: Extremely rare 1930s K2 phone box at the side of the Town Hall, Castle Street.

Above right: Two different types of phone box at the side of the Town Hall, Castle Street.

Perforated crown logo on top of the K2 phone box at the side of the Town Hall, Castle Street.

Although deigned in a classical style, the design incorporated some advanced features, such as having three sides made out of small panes of glass, in order to make breakages cheaper to replace than a large single pane. The crowns stamped into the top of the dome are not merely for decoration; they also double as ventilation holes.

Between 1926 and 1935, only 1,700 K2s were installed, but their cost and weight (being made out of cast iron) meant that very few were installed outside of London. Today, only 224 are still in existence on the nation's streets, with most of them being awarded Grade II listed status from English Heritage. The K2 that stands at the side of the Town Hall is therefore extremely rare, especially as it is still in full working order.

Next to the K2 stands a newer design, a Kiosk No. 6 (or K6). Scott was invited back by the Post Office to design a new version of his classic phone box, in order to commemorate King George V's silver jubilee in 1935. Over 60,000 K2s were installed all over the UK, of which around 11,000 still survive. The K6 became an iconic symbol of Britain, in much the same vein as the bulldog and Mini.

However, with the invention of the mobile phone, the red phone box's days are numbered; every year hundreds of them are removed from our streets due to a drastic reduction in use, coupled with the increasing cost of maintenance and repair. Eventually these iconic structures will disappear from our streets forever, so appreciate them while you still can.

WATER STREET - GOLD, OCTOPI AND LUCKY TIGERS TEETH

Martin's Bank, 4 Water Street

Just across the road from the Town Hall phone boxes stands the magnificent former Liverpool head office of Martin's Bank. Designed by Herbert Rowse and opened in 1932, the sculptured adornments on the building are the work of George Herbert Tyson Smith, a highly skilled and talented sculptor, whose work can be seen on many of the city's buildings

Martin's Bank, 4 Water Street.

Hidden octopus carving under the upper balcony, Martin's Bank, Water Street.

and memorials. Although his fine sculptures can be seen all over this imposing building, there are a few pieces of his work that are hiding in plain sight. If you look at the underside of all six-window balconies that jut out from the upper floors of the building, you can see a stylised carving of an octopus on each.

Martin's Bank's finest hour occurred during the Second World War; in 1940, Britain was under increasing threat of German invasion after the defeat of the Allied Forces in France, culminating in the evacuation from Dunkirk. In a bid to safeguard the nation's gold reserve, The Bank of England made the decision to move a large portion of it out of London and hide it in a secret location. Since the Liverpool head office of Martin's Bank had a very secure strong room, with a basement built on solid rock, walls and ceilings made out of reinforced concrete over a metre (three feet) thick, and steel doors weighing 9 tons, it was adjudged to be the ideal place to store the gold by The Bank of England.

The gold was moved to Liverpool via three trains, the first of which arrived on Lime Street station's platform eight at just before midnight on 22 May 1940. It took nearly three hours to load the consignment onto lorries, and then the gold was driven to the bank under cover of darkness.

Because the bank's bullion lift was not up to the job of handling so much weight, the gold had to be manually lowered down a hatch at the side of the bank and wheeled on a trolley down a corridor to the bank's strong room. It was a very hard work, with the loading being

The hatch used to get the nation's gold reserve into Martin's Bank during the Second World War, Water Street.

completed just a short while before the bank was due to open its doors for the morning customers. This exercise was repeated on two more occasions. In total, 4,719 boxes of gold bullion were moved into the bank, weighing in total 280 tons.

Getting the gold into the bank was relatively easy. However, since it was only being stored in the bank temporarily until it could be safely shipped out of the country to Canada, it was necessary to install a new heavier-duty bullion lift to make the task of removing the gold manageable. One month later, the gold set sail for Canada where it was safely stored for the duration of the war.

It gave the staff at Martin's Bank a sense of pride to have played a significant part in the Allied war effort, and to have been, if only for a short time, the custodians of most of the nation's wealth.

In 1993, the BBC filmed a drama based on the event called 'The Bullion Boys'. It was filmed in the bank using the very same rooms that were originally used for the operation.

Tiger's Heads, 7 Water Street

Across the road from Martin's Bank is the former National & Provincial Bank. Although the bulk of the building was built in the 1890s, the original front of the building was replaced with a more modern-looking design in the 1930s. If you walk round the corner into Fenwick Street you can see the join, with the original walls being made of sandstone decorated with an interlacing Celtic pattern.

Former National & Provincial Bank, 7 Water Street.

Above left: Tiger's head, 7 Water Street.

Above right: Tiger's lucky teeth, worn down over the years by sailors rubbing them for luck before setting sail.

Left: Tiger's head, 7 Water Street.

The most remarkable feature on the building are the bronze tigers' heads that are mounted on the walls either side of the entrance way. It is amazing how many people, who walk up and down this street on a daily basis, are not aware of their existence. If you take a closer look at the sculptures you will notice that the tiger's teeth look very worn and shiny compared to the rest of the head. This is because Lascar (Indian) and Somali Sailors, who were employed in large numbers in Liverpool as sailors in the late 1800s, believed that stroking the tiger's teeth before setting sail would bring them good fortune.

BANKSY'S LOVE PLANE

Rumford Street Car Park

Although we have already mentioned the Street Artist Banksy earlier in this book (see section on Bold Street) and his spraying spree around the Ropewalks area of the city in 2004, he visited Liverpool again in 2011 to create another large piece of work on the side of a building next to a car park on Rumford Street. Dubbed 'Banksy's Love Plane', this 3-metre-tall (fifteen-foot) mural depicts a biplane leaving a heart shaped vapour trail in its wake. It is a much softer, more whimsical piece than Banksy's usual output of biting satire and social commentary, but it is no less brilliant in its execution. Unfortunately, within the first few days of it appearing, part of it had been painted over with the words 'Banksy 4 Robbo'.

Banksy's *Love Plane*, Rumford Street.

Cheeky addition to Banksy's *Love Plane* mural, Rumford Street

Speculation was rife that the perpetrator had been a follower of rival graffiti artist 'King Robbo', with whom Banksy has been involved in an ongoing feud since the late 1990s.

The 'Banksy–King Robbo' war, as it has been called, is the stuff of legend amongst the Graffiti Artist community. It began in the late 1990s when Robbo was introduced to Banksy in a pub. At that time, Robbo was a legend in graffiti circles and Banksy was a relative newcomer to the scene. Robbo greeted Banksy with 'Oh yeah, I've heard of you mate, How you doing?' to which Banksy replied 'Well, I've never heard of you,' in a very dismissive tone. Robbo playfully cuffed him round the ear and said 'Well, you won't forget me now, will you!' Ever since, the pair have been fighting a tit-for-tat war on the streets by defacing each others' work.

The unwanted graffiti was quickly removed from the Love Plane and someone bolted large Perspex sheets over the work to protect it from further damage by vandals. However, in December 2013 the artwork gained another, far cheekier, addition below the Perspex, a stencilled Rat with paintbrush in hand writing the words 'Never liked this Banksy'. The rat is a parody of the Graffiti Rats that Banksy had left all over the Ropewalks area during the 2002 Biennial.

At the time of the first addition, King Robbo was in a coma after a serious fall, but had made a full recovery by 2013. This had led people to speculate that it was Robbo himself who had made the ratty addition to the Love Plane. If so, the bizarre street war continues on the streets of Liverpool.

Banksy's Love Plane, and the rat, are well worth a look, but bear in mind the transient nature of street art – one day it is here, the next, gone forever. Catch it while you can.

THE OLD DOCK

Liverpool One

Opposite the Lewis's department store in Liverpool One is a circular window set in the pavement, surrounded by a silver barrier. Curious shoppers occasionally stop and peer into the window and wonder what lies below. Right under their very feet is possibly the most important structure in the history of Liverpool, a construction that not only made Liverpool the city it is today, but also was instrumental in helping Great Britain to expand its empire right round the globe. For below the shoppers' feet lies the world's first commercial enclosed wet dock.

In 1709 Liverpool Council had been given permission to build a new type of dock in the city and was granted £12,000 in funds to make it happen. However, they did not have a civil engineer to lead the project. At the recommendation of the then Lord Mayor, the Earl of Derby, they hired his friend, Thomas Steers, who at the time just happened to be staying with the Earl in Liverpool.

Nothing is really known about Thomas Steers, except for the fact that he appeared to be well connected to highly influential people. He certainly did not appear to have much of a civil engineering background. On the recommendation of the Earl of Derby alone, it appears, he became the man who the city of Liverpool pinned their very future on.

Circular window looking into the Old Dock, Liverpool One.

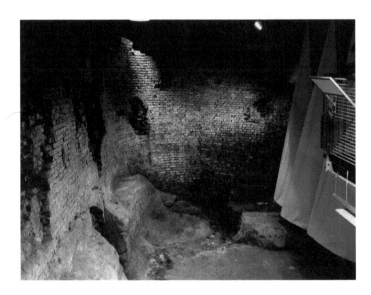

The Old Dock, Liverpool One.

As well as the £12,000 already granted, an additional £50,000 had to be raised for the construction of warehouses, which were essential for any dock to function properly. To give an idea of how colossal a sum of £62,000 was in 1709, the average wage for a labourer at that time was around £20 per year! It was a massive investment and a very risky venture to undertake. The future of Liverpool literally hung in the balance.

Construction of the dock began in 1710 and was completed in 1715. The first ship to sail into the new dock was called the Mulberry, which docked on 21 August of that year. The Dock was officially opened in 1719.

The wet dock differed from other docks in the city in one important respect. At the dock entrance, huge wooden gates were fitted which, when closed, trapped the water inside the

dock, meaning that the water level inside was kept at a more or less constant level. This had a huge impact on the time it took to load and unload cargo from ships. Before the creation of the wet dock, ships could only be loaded and unloaded when the water was at high tide, allowing just a few hours every day to move cargo. The new dock, with its giant water trapping doors, cut down the average time of loading and unloading a ship from two weeks to two days. Ships could now sail more frequently and hence increase trade and profits.

Because of this innovation, traders flocked to the city to do business. For the first time in its history, Liverpool became the gateway to the Empire. It is estimated that, at that time, around 41 per cent of the World's trade entered Britain through Liverpool, and over 45 per cent of Britain's exports left here as well. As a consequence, Liverpool became a very wealthy city.

However, the new dock was not without its problems. Because it had been constructed from clay bricks, rather than more traditional harder materials, the walls were prone to damage from ships whenever they crashed into the dock sides, which was costly in both the time and money needed effect repairs. The lessons learned from the mistakes made on this dock were put to use in Steer's later projects. Because of the huge amount of money generated by the increased trade, the Liverpool Corporation built more docks to cope with the increase in shipping traffic. This led to an expansion of the port area, along with an increase in the amount of accommodation and facilities for the rising numbers of workers and traders living in the city. It was a time of rapid growth for the city.

The dock operated steadily for the next 111 years until finally closing down in 1826. The closure came about for two reasons. Firstly, ships were rapidly growing in size, meaning that the dock was becoming too small to handle most ships, and secondly, throughout its life, the dock had also been used as a sewer outlet for the city's sewage. By 1826, the sewage problem was exacerbated by an outbreak of cholera, which necessitated the docks closure for health reasons. The dock was drained and filled with concrete and rubble. The land was levelled and a new Customs house was constructed on the spot in 1839. This remained until being damaged in the May Blitz in 1941 and was eventually pulled down in 1948. The land was later used for the construction of office blocks. In time these too were demolished.

In 2001, during the construction of Liverpool One Shopping Area, the developers allowed a team of archaeologists to excavate the site. To their delight, the archaeologists discovered that the old dock was still in good shape despite being buried since 1826. The developers, realising the dock's importance to the history of Liverpool, took steps to help preserve the site and to provide access to the public for viewing a portion of it.

As stated previously, this site is literally *the place* where Liverpool began; the spot where the 'Pool of Life' that gave the city its name originated. It is an essential place to visit for anyone interested in the history of the city.

How to see the Old Dock

Access to the Old Dock can be obtained by contacting the Merseyside Maritime Museum and booking a place on their excellent (and free) tour. The guides do an excellent and highly entertaining tour and presentation of the Old Dock site, including a whistle-stop tour of the symbolic architectural features incorporated into the layout of Liverpool One. It is highly recommended.

To book a place on the tour, call the Merseyside Maritime Museum on 0151 207 0001.

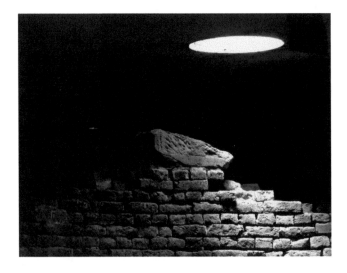

The original copingstones that capped the walls of the Old Dock.

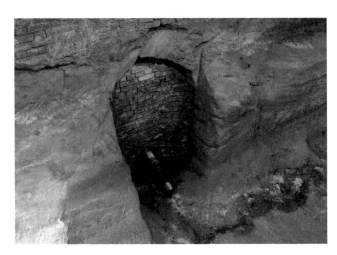

A tunnel exit at the bottom of the Old Dock discovered during excavations – possibly an escape tunnel from the old Liverpool Castle.

The bedrock of the original pool that gave Liverpool its name.

Right: Jezz and Danny, the highly entertaining guides for the Old Dock Tour.

Below: William Hutchinson fountains, Liverpool One.

Further Reading

1 Ancient Liverpool

Formby Footprints
Information Booklet:
The Lost World of Formby Point: Footprints on the Prehistoric Landscape, 5000 BC to 100 BC, by Gordon
 Roberts, ISBN 978-0-9508-1552-7
Gordon Robert's excellent Formby Footprints website: http://formby-footprints.co.uk/index.html
The Archer Stone / Calderstones
Mike Royden's Local History Pages: http://www.roydenhistory.co.uk/mrlhp/local/calders/calders.htm
Calderstones Park official website: http://liverpool.gov.uk/leisure-parks-and-events/parks-and-
 greenspaces/calderstones-park/

2 Suburban Secrets
GHOST SIGNS

Liverpool Ghost signs: A Sideways Look at the City's Advertising History by Caroline & Phil Bunford,
 History Press. ISBN 978-0-7524-6570-8
Ancient Chapel of Toxteth
'Ancient Chapel of Toxteth Information booklet' – Bernard Cliffe - available from the Chapel for a small
 donation
Some Account of the Ancient Chapel of Toxteth by Valentine D. Davis, Harvard College Library 1884 Online
 book https://archive.org/stream/someaccountancioomathgoog/someaccountancioomathgoog_djvu.
 txt
Dingle Tunnel & Overhead Railway

Lost Lines – Liverpool & The Mersey by Nigel Welbourn, Ian Allan, ISBN 978-0-7110-3190-6

3 City Centre Wonders

Pevsner Architectural Guide to Liverpool by Joseph Sharples and Richard Pollard ISBN 0-300-10258-5
Discover Liverpool by Ken Pye, Trinity Mirror, ISBN 978-1-9052-6635-7
Anglican Cathedral website: http://www.liverpoolcathedral.org.uk/
The Cavern website: http://www.liverpooltours.com/cavern73.htm
The Cavern, The Most Famous Club in the World by Spencer Leigh, SAF Publishing Ltd, ISBN
 978-0-9467-1990-7
Erics
Liverpool Eric's - all the best clubs are downstairs, everybody knows that... by Jaki Florek & Paul Whelan,
 Feedback, ISBN 978-0-9540-3262-3
Liverpool Music
The Beat Goes on: Liverpool, Popular Music and the Changing City edited by Marion Leonard & Rob
 Strachan, Liverpool University Pres, ISBN 978-1-8463-1150-1

4 A Walk Around the Business Quarter

Martin's Bank Gold Bullion story
http://www.martinsbank.co.uk/Martins%20at%20War%20-%twentiethe%20Bullion%20boys.htm